W9-COG-733

The Young Vermeer

This book was published to accompany
the presentation *The Young Vermeer*

Royal Picture Gallery Mauritshuis,
The Hague
12 May – 22 August 2010

Gemäldegalerie Alte Meister, Staatliche
Kunstsammlungen, Dresden
3 September – 28 November 2010

National Gallery of Scotland, Edinburgh
10 December 2010 – 13 March 2011

The presentation in The Hague has been
made possible by the generous support
of the City of The Hague, the Prins
Bernhard Cultuurfonds and the Nieske
Fonds, administered by the Prins Bernhard
Cultuurfonds.

The Young Vermeer

Edwin Buijsen

with a contribution by Geerte Broersma

Royal Picture Gallery Mauritshuis, The Hague
Waanders Publishers, Zwolle

Contents

7 Foreword

18 Vermeer's Early Career
Edwin Buijsen

54 The Rediscovery of the 'Young Vermeer'
Edwin Buijsen

74 Vermeer, Vermeer and Vermeer
Geerte Broersma

78 Works Exhibited

84 Notes

88 Bibliography

Foreword

For many visitors to the Mauritshuis, the Vermeer Room is the high point of their tour around the museum. Travel journals, guestbooks and these days also blogs testify to the emotions aroused in people who have stood, transfixed, in front of *View of Delft* and *Girl with a Pearl Earring*. These two masterpieces by Johannes Vermeer have become icons of Western art and are naturally arresting, but visitors often fail to notice the third Vermeer hanging in the same room: *Diana and her Nymphs*. This colourful depiction of a mythological subject does not fit Vermeer's image as a painter of intimate domestic scenes. It was painted at the beginning of his career, when he was still searching for a style of his own. Two other paintings from this early period (1653–1656) also differ from his later work: *Christ in the House of Martha and Mary* in the National Gallery of Scotland in Edinburgh, and *The Procuress* in the Gemäldegalerie Alte Meister, Staatliche Kunstsammlungen, in Dresden. In close association with both museums, these three early paintings have been brought together in the Mauritshuis in the presentation *The Young Vermeer*, which will later travel to Dresden and Edinburgh.

This small exhibition brings a little-known side of the famous painter to the attention of the public for the first time. *The Procuress* from Dresden was not part of the large Vermeer exhibition mounted at the Mauritshuis in 1996.

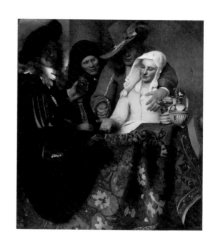

Moreover, recent conservation treatment of the paintings in Dresden and The Hague has provided a wealth of new information on the artist's working method and artistic development. The young Vermeer must have studied the work of Dutch, Flemish and Italian masters closely, and absorbed these influences to form a style of his own. The fascination he had — even in those early days — for stillness, light, and compositional harmony anticipates his later work. In the Mauritshuis the three early Vermeers will be shown near *View of Delft* and *Girl with a Pearl Earring*. Visitors to the presentation have the opportunity to admire no fewer than five paintings by Vermeer and discover for themselves the differences between his early and late work.

At the other venues, the curators in charge of this presentation were Uta Neidhardt (Dresden) and Christian Tico

1 The three early works by Vermeer (cat. nos. 1–3).

Seifert (Edinburgh). At the Mauritshuis this task was fulfilled by Edwin Buijsen, who also took responsibility for the publication that accompanies the presentation in The Hague. This booklet not only examines the young Vermeer's training and artistic development, but also recounts the rediscovery of his early works in the late nineteenth and early twentieth centuries. Dorine Duyster edited the Dutch texts, and Diane Webb translated them into English. Victor de Leeuw was responsible for the book's design, which he introduced with the Mauritshuis publications *Jacob van Ruisdael paints Bentheim* and *Room for Art in Seventeenth-Century Antwerp*.

At the Mauritshuis, deputy director Victor Moussault, project leader Antia Wiersma and the other members of the project group — Liana Knap, Epco Runia, Bibian Sibbing and Iris van Eendenburg — played an important role in the realisation of this project.

The presentation at the Mauritshuis was made possible by the generous support of the City of The Hague, the Prins Bernhard Cultuurfonds and the Nieske Fonds, administered by the Prins Bernhard Cultuurfonds. The Young Vermeer is part of the core programme of Holland Art Cities 2010. This presentation has also been made possible through an indemnity grant provided by the Dutch Ministry of Education, Culture and Science.

Finally, I would like to thank Prof. Bernhard Maaz, Director of the Gemäldegalerie Alte Meister in Dresden, and Michael

Clarke, Director of the National Gallery of Scotland in Edinburgh, for their willingness to part temporarily with their valuable paintings.

For me personally, this presentation is especially significant: as former Senior Curator of Early Netherlandish, Flemish and Dutch Art at the National Gallery of Scotland, I am extremely pleased to see a painting I came to know well in Edinburgh on display in the Mauritshuis, alongside *Diana and her Nymphs* and the Dresden picture. I hope that making the acquaintance of the young Vermeer will be a special experience, not just for me, but for all our visitors.

Emilie Gordenker
Director, Mauritshuis

Johannes Vermeer, *Diana and her Nymphs* (cat. no. 1),
The Hague, Mauritshuis (see also the following pages).

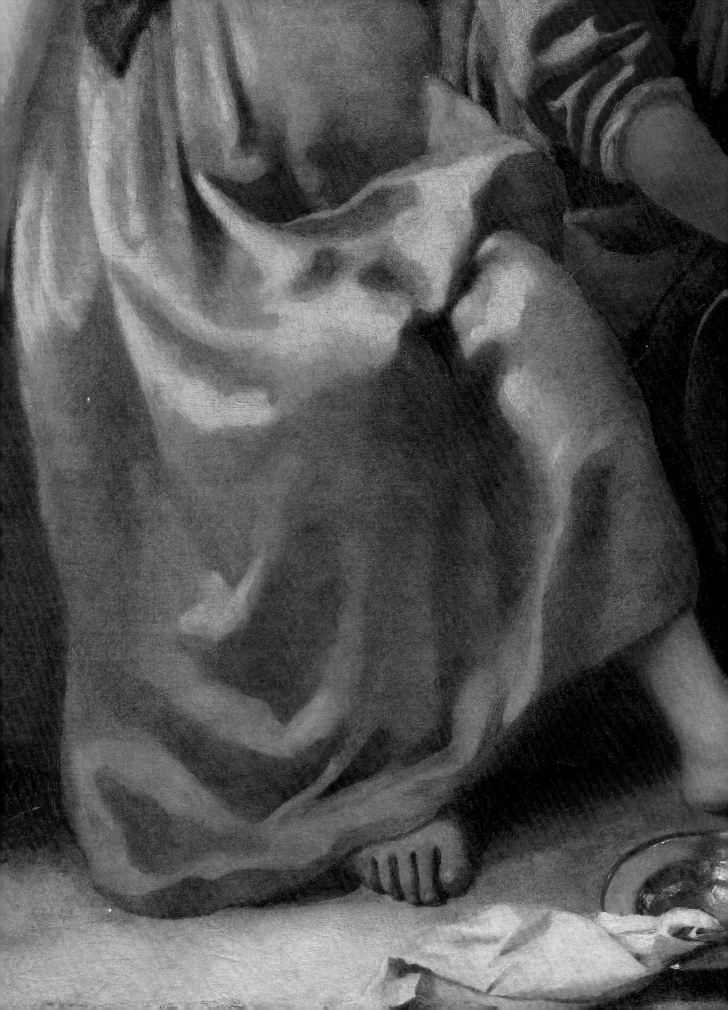

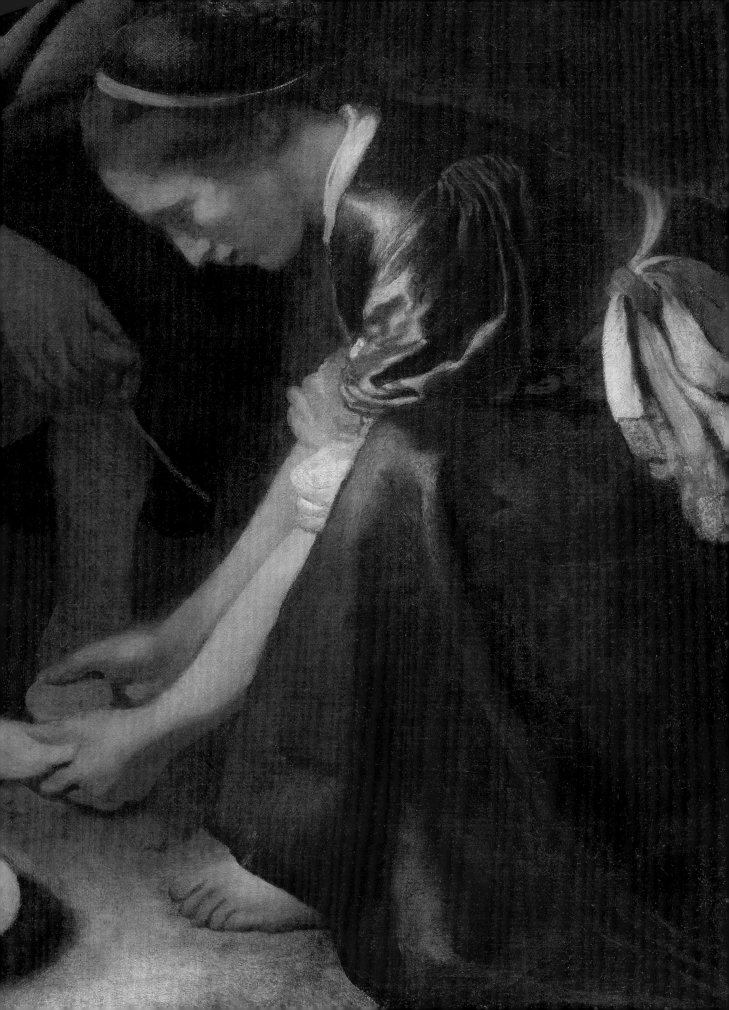

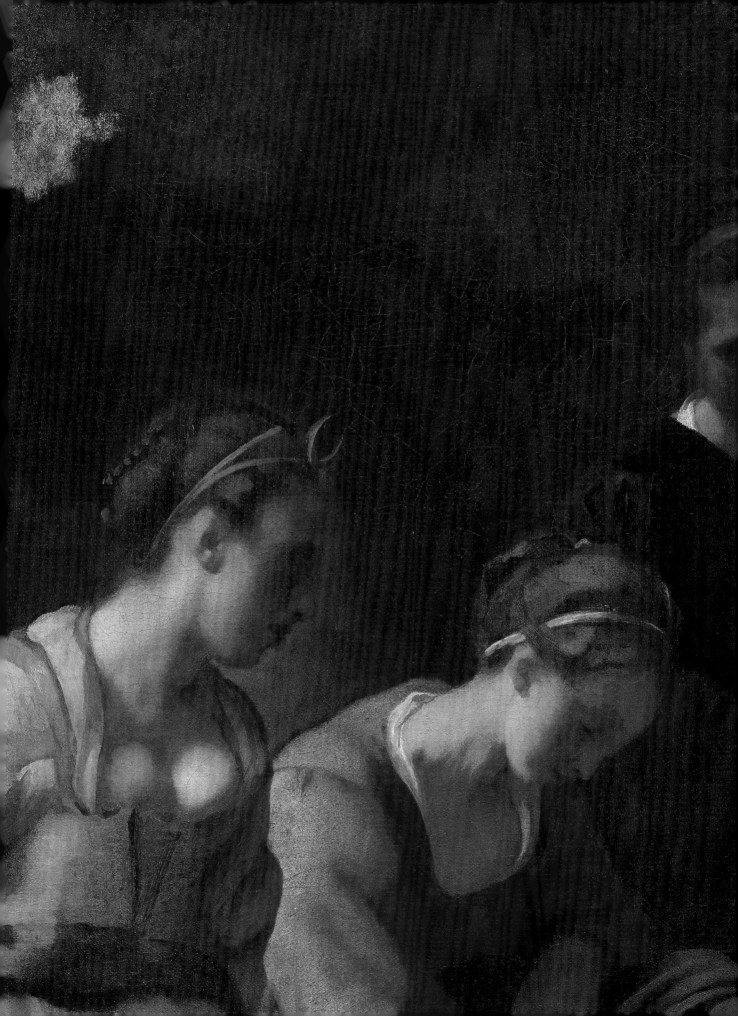

Vermeer's Early Career

Edwin Buijsen

The paintings of Johannes Vermeer (1632–1675) are now world-famous. His small but superb oeuvre — some 36 works[1] — consists mostly of interiors with one or two figures quietly engaged in everyday activities, such as pouring milk, making lace, playing musical instruments, or reading or writing a letter. We also know a few 'tronies' — studies of a facial expression or a character type, such as *Girl with a Pearl Earring* — and two townscapes, including *View of Delft*. Vermeer began his career, however, making paintings of a very different kind. His three earliest works — *Diana and her Nymphs*, *Christ in the House of Martha and Mary* and *The Procuress* — clearly differ from the paintings that made him famous. Not only do they depict themes not found in Vermeer's later oeuvre — a mytho-logical subject, a story from the Bible and a brothel scene – but they are remarkably large compared with his other works. Their subject matter and palette were inspired by examples from Dutch, Flemish and Italian masters, but Vermeer assimilated these influences in a manner all his own. The artist was searching for an individual style, but his obvious interest in composition, light and tranquillity anticipates his later development.

With whom did Vermeer study?
On 29 December 1653, eight months after marrying Catharina Bolnes (c.1631–1688), 21-year-old Johannes Vermeer registered as a master-painter with the Guild of St Luke in his native city of Delft, where he continued to live and work (fig. 2). From then on he was considered a fully fledged, independent painter, and was therefore allowed to sign and sell his own work. Even

though in recent decades archival research has uncovered much more information on Vermeer and his family, no documents have yet surfaced that reveal where and with whom he studied painting.[2] One thing we do know is that he grew up in a family in which art was part of daily life. In 1631 his father, Reynier Jansz (c.1591–1652) — initially a weaver of caffa (a silk cloth similar to damask) — registered as a 'master art dealer' ('Mr. Constvercoper') with the Delft Guild of St Luke.[3] There are documents showing that Vermeer's father maintained ties with local painters, such as Balthasar van der Ast (1593/94–1657), Pieter Steenwijck (c.1615–after 1656), Pieter van Groenewegen (c.1600–1658), Evert van Aelst (1602–1657) and Egbert van der Poel (1621–1664). He was also on good terms with the notary and art lover Willem de Langue (1599–1656), who was a key figure in Delft art circles (fig. 3).[4] In addition to dealing in art, Reynier Jansz was an innkeeper, and the establishments he ran — first 'De Vliegende Vos' ('The Flying Fox') on the Voldersgracht and after that, starting in 1641, the 'Mechelen' on the Markt — probably doubled as galleries, which was a common practice in those days. At first he was known by his nickname, 'Vos', but in 1640 he started to call himself 'Vermeer'. This contraction of 'Van der Meer' had been used previously in the family. His only son — Johannes, born in 1632 — would eventually make this name famous.

In 1638 Reynier Jansz and his wife, Digna Baltens (c.1595–1670), had a will drawn up by Willem de Langue. It stipulated that in the event of the death of either parent, the surviving spouse was to guarantee their children — Johannes and his older sister, Gertruy — a good education and

2 Johannes Vermeer's registration in the *Meesters-bouck behoorende onder Ste Lucasgilde*, 1653. The Hague, National Library (KB).

make sure they learned a 'trade'. It is not known exactly when Johannes decided to become a painter. Artists could not join the Delft Guild of St Luke until they had completed at least six years of training,[5] so Johannes's registration as a master-painter at the end of 1653 suggests that he began to train in 1647–1648.

The extensive literature on Vermeer puts forward various names as his possible teachers. At first it was assumed that he and Nicolaes Maes (1634–1693) had studied in Amsterdam with Rembrandt, but this theory did not hold up for long.[6] The suggestion that he had received instruction in Delft from Carel Fabritius (1622–1654), active there since 1650

3 Willem van der Vliet, *Portrait of Willem Reyersz de Langue*, 1626. Panel, 113.2 × 86.3 cm. Delft, Museum Het Prinsenhof.

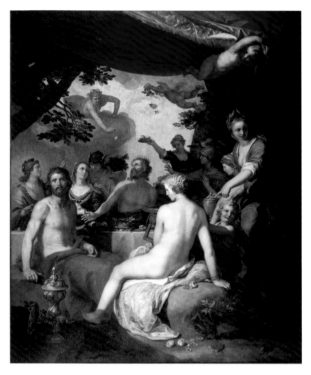

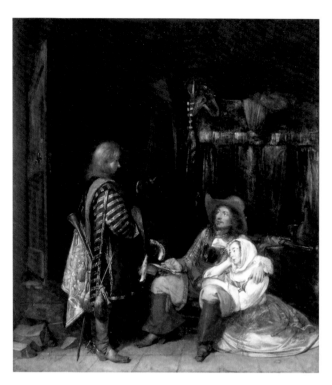

4 Abraham Bloemaert, *The Feast of the Gods at the Wedding of Peleus and Thetis*, 1638. Canvas, 193.7 × 164.5 cm. The Hague, Mauritshuis.

5 Gerard ter Borch, *Messenger, known as 'Bad Tidings'*, 1653. Panel, 66.7 × 59.5 cm. The Hague, Mauritshuis.

6 Carel Fabritius, *A View of Delft*, 1652. Canvas, 15.4 × 31.6 cm. London, The National Gallery, presented by the National Art Collections Fund, 1922.

7 Records of the notary
Willem de Langue, with
the signatures of
Gerard ter Borch,
Johannes Vermeer and
Willem de Langue,
22 April 1653. Delft,
Municipal Archives.

(fig. 6), found more favour. This notion was based in part on a poem composed in 1667 by their fellow townsman Arnold Bon, who stated that Vermeer had followed in Fabritius's footsteps,[7] though this does not necessarily imply a master-pupil relationship. Fabritius did not register with the Guild of St Luke until October 1652, a mere fourteen months before Vermeer. Before that time he would not have been allowed to take on pupils, so any instruction Vermeer might have received from Fabritius could not have lasted very long.

Another candidate is Leonaert Bramer (1596–1674), who specialised in history paintings with numerous figures and strong lighting effects (fig. 8). Bramer was one of Delft's leading painters, and documents attest to his good relations with Vermeer and his family.[8] He witnessed the reading of Johannes's marriage banns in April 1653 (see p. 30), but there is nothing in the sources to suggest that Vermeer was his pupil. Another artist who knew the young Vermeer personally was Gerard ter Borch (1617–1681), the famous portraitist and genre painter (fig. 5). In April 1653, both Vermeer and Ter Borch signed an act drawn up by the notary De Langue in Delft (fig. 7). There is no proof, however, that Vermeer studied with Ter Borch, who probably stayed in Delft only briefly on his way from The Hague to his home in Zwolle.[9]

Because Vermeer's early work betrays the influence of artists from both Amsterdam and Utrecht, it has been assumed that he received part of his training in one or both cities. As far as Utrecht is concerned, the versatile Abraham Bloemaert (1566–1651) is a possible candidate (fig. 4), because he trained a great many painters and was also related to Vermeer's in-laws. It has even been suggested that Bloemaert introduced Vermeer to his future wife.[10] When Vermeer registered with the Guild

8 Leonaert Bramer, *An Egyptian Servant Brought Before King David*, c.1640. Panel, 59 × 72 cm. Delft, Museum Het Prinsenhof

of St Luke in Delft, he was charged the full, six-guilder membership fee, only one-quarter of which he could afford to pay immediately (see fig. 2). Sons of guild members were admitted at the reduced rate of three guilders, provided they had been apprenticed for at least two years to a local master. Vermeer's father was a guild member, but the fact that Johannes was not entitled to this discount suggests that he had, in fact, received some of his training elsewhere.[11]

Another theory is that Vermeer was required to pay the full amount because he did not serve the customary apprenticeship, but was, instead, largely self-taught.[12] A complete painter's training was costly, and his father was heavily in debt after buying the Mechelen Inn. It is possible, therefore, that Reynier Jansz asked a painter friend to act as his son's 'unofficial' master and teach him the rudiments of painting. Johannes would then have continued to develop on his own, drawing inspiration from the paintings that passed through his art-dealing father's hands. This remains hypothetical, yet it would explain why his early work

does not bear the stamp of any one artist, but displays many different influences, absorbed in an entirely idiosyncratic way. Until the discovery of unambiguous evidence, however, Vermeer's training will remain a mystery.

Beginnings as a history painter

The subjects of the two earliest known paintings by Vermeer were taken from classical mythology (*Diana and her Nymphs*; see pp. 26–29, fig. 9) and the New Testament (*Christ in the House of Martha and Mary*; see pp. 30–35, fig. 15). Such representations based on existing stories (histories) are called history paintings. In the eyes of seventeenth-century art theorists, history painting was the highest rung on the artistic ladder.[13] Ideally, the artist began by delving into the written sources and then gave free rein to his imagination, in order to portray the story convincingly. This required, above all, the proper arrangement of the figures ('ordinantie') and the compelling rendering of their emotions ('affecten'). According to theorists, this task placed greater demands on the painter than the mere imitation of the real world seen in such genres as animal painting, still life, landscape, interiors and portraiture. In practice, however, many Dutch painters devoted themselves to these 'lesser' subjects anyway, for the simple reason that they were in greater demand. Nevertheless, it was quite common for artists to try their hand at history painting at the beginning of their careers, since this enabled them to master the techniques of painting before choosing the specialism that suited them best or proved the most profitable. Examples include the landscape painter Aelbert Cuyp, the animal painter Paulus Potter, the architectural painter Emanuel de Witte, the genre painter Gabriel Metsu and the Italianate

landscapist Nicolaes Berchem[14] — and, of course, Johannes Vermeer.

The two earliest works by Vermeer are remarkably ambitious, both in size and subject matter. These pictures, which are filled almost entirely with large, full-length figures, seem to have been painted not only as proof of Vermeer's skill, but presumably because he truly hoped to project an image of himself as a history painter. The sources suggest that early in his career he produced other history paintings that are now no longer known. The inventory of Johannes de Renialme, an Amsterdam art dealer with good contacts in Delft, lists 'Visitors to a tomb, by Van der Meer'.[15] This was undoubtedly an image of the Three Marys at the Sepulchre, a story from the New Testament. The record of this painting in De Renialme's inventory dates from 27 June 1657, so it must have been an early work. In 1761 a painting of a mythological subject was sold at auction as 'Jupiter, Venus and Mercury by J. ver Meer'. It came from the collection of the prominent Delft family of Van Berckel and had possibly been in their possession for a long time.[16]

Clearly, our current picture of the young Vermeer as a history painter is far from complete, so it is risky to draw sweeping conclusions about his early years as an artist. Nor is the chronology of the two earliest works clear, since neither bears a date. They can be assigned roughly to the period between late 1653, when Vermeer became an independent painter, and 1656, the year in which he made *The Procuress* (fig. 23). As will be shown, the latter painting is closer to his later oeuvre than the two history paintings. Because the composition of *Christ in the House of Martha and Mary* is more daring and ambitious, it is dated slightly later than *Diana and her Nymphs*, but the two works must have been produced in close succession.[17]

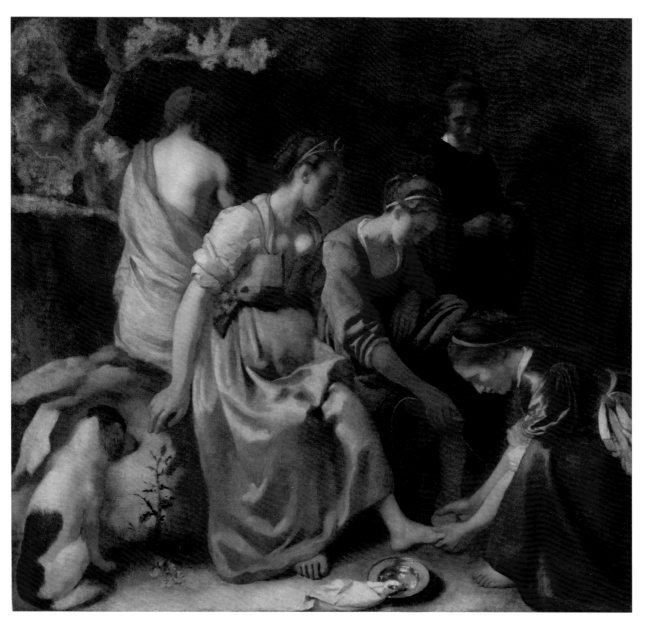

9 Johannes Vermeer, *Diana and her Nymphs*, c.1653–1654. Canvas, 97.8 × 104.6 cm. The Hague, Mauritshuis (cat. no. 1).

Diana and her Nymphs

circa 1653–1654

Vermeer presumably completed *Diana and her Nymphs* (fig. 9) shortly after registering as a master-painter. The serenity of the scene and its dreamy atmosphere are striking. Five young women avoid looking at one another in this scene of repose. Their faces, inasmuch as they are visible, are largely hidden in shadow. If the woman in the yellow gown were not wearing a diadem with a crescent moon — the attribute of Diana, goddess of the moon and of the hunt — the painting would not be easily recognisable as a scene from classical mythology.

The *Metamorphosis* by the Roman poet Ovid (BC 43 –17 AD) includes two stories about Diana and her companions, which emphasise the purity of the chaste goddess. In one of the stories, the company is surprised while bathing by the hunter Actaeon, who — as punishment for laying eyes on the naked goddess — is turned into a stag and subsequently torn to pieces by his own hounds. In the other story, Callisto, one of Diana's nymphs, is similarly punished when it becomes apparent, as she undresses to bathe, that she is pregnant. Both tales were popular among painters because they offered — despite their warnings against lewdness — ample opportunity to depict the female nude and a great deal of action.[18] In these works by Vermeer, however, there is no sign of any excitement whatsoever. The women all have their clothes on — only the figure at the far left reveals her partly bared back — and a mood of undisturbed intimacy and harmony prevails. As in some other representations of Diana and her companions (see, for example, fig. 13), there is no clear narrative. It has been suggested that the woman standing at the back on the right is the nymph Callisto, because she is dressed from head to toe and clutches her hands protectively against her body.[19] According to Ovid,

she refused at first to undress, fearing that her pregnancy would be discovered. If this figure is indeed Callisto, the painter has done his utmost to suggest her identity as discreetly as possible.

The picture's intimate character is heightened by the dark, enclosing background. That this was the artist's intention did not become clear until the most recent conservation treatment of the painting in 1999–2000.[20] Until that time, blue sky and clouds filled the upper right section of the canvas (fig. 10). Technical research has shown that this sky could not have been original, since the paint was found to contain the pigments Prussian blue and chrome green, which were not available in Vermeer's day.[21] It must therefore be a later overpainting. Examination of cross-sections also showed that the underlying paint in this passage is similar, in terms of the build-up of the paint layer, to the dark areas in the tree passages elsewhere in the background. During conservation treatment, it was decided to reconstruct the original state by covering the blue sky with a thin, neutral overpainting in a dark brown tone in keeping with the rest of the background. Now that the sky at the upper right is obscured, the light falling onto the figures from the left gains in importance, clearly revealing how Vermeer played with light and colour. It was also discovered during treatment that the canvas had been cropped approximately 12 centimetres on the right-hand side.[22] A digital reconstruction of the original format shows that the woman kneeling at the lower right must have appeared fully in the picture (fig. 11), making the composition more balanced and placing the focus on Diana's foot-washing. Combined with the basin and the cloth at her feet, this cleansing act was probably meant to emphasise the goddess's chastity.[23]

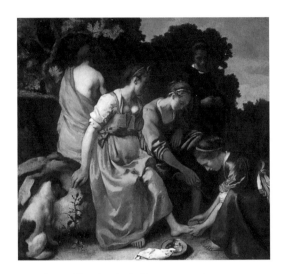

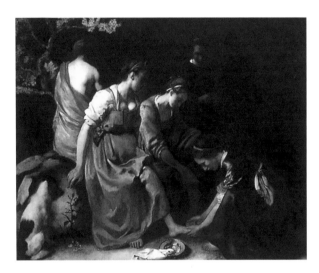

10 *Diana and her Nymphs*: before conservation treatment in 1999–2000.

11 *Diana and her Nymphs*: digital reconstruction of the original format.

Even after the discovery in 1885 of the signature on the boulder at the lower left, art historians were still hesitant to attribute the painting to Johannes Vermeer of Delft (see p. 80, fig. 48a–d; see also pp. 57–62). Their uncertainty was no doubt prompted by the subject matter, which was atypical of Vermeer, as well as by the painting's poor condition, which made it difficult to assess. During the 1999–2000 conservation treatment, the old varnish and overpaintings were removed and new, smaller retouches applied to numerous worn spots, so that it is now easier to judge the painting technique.[24] The brass basin in the foreground was rendered with great attention to detail; the reflections of light on the metal were carefully applied with thick strokes of paint (fig. 12). Other details are somewhat less successful, such as the boulder on which Diana is seated, whose form and texture are more reminiscent of a bag of laundry than of stone. The folds in the clothing look stiff and

forced in places. Moreover, some of the figures are anatomically awkward, particularly the elongated figure seen from the back, on the left. This all goes to show that we are dealing with a young, inexperienced artist, who had not yet acquired all the necessary skills.

12 *Diana and her Nymphs*: detail of the basin.

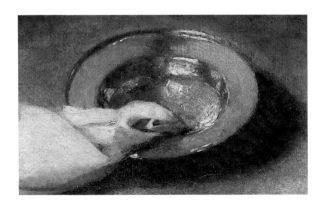

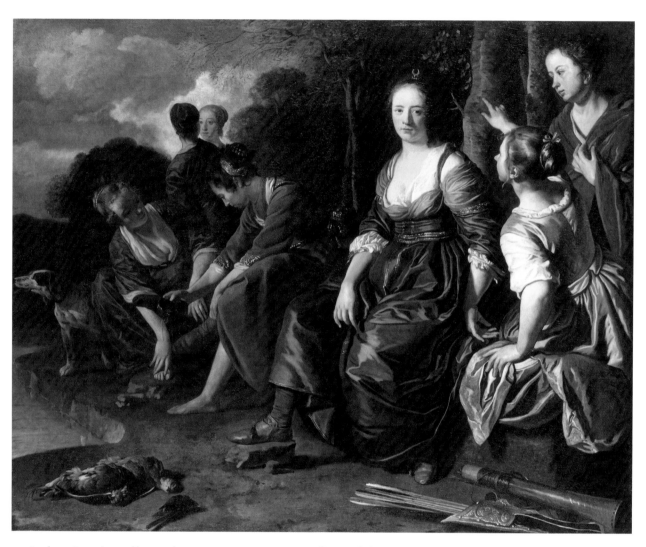

13 Jacob van Loo, *Diana and her Nymphs*, 1648. Canvas, 134 × 167 cm. Berlin, Staatliche Museen, Gemäldegalerie.

The fact that Vermeer decided not to paint female nudes, even though the subject offered the perfect opportunity to do so, might indicate that he had never received any training in anatomical drawing.[25] In any case, this discipline probably did not appeal to him, since nudes do not appear in his later work either, and as far as painting live animals was concerned, he confined himself to the dog in this picture.[26] History painting offered young artists the perfect chance to become familiar with their strengths and weaknesses. *Diana and her Nymphs* already shows that Vermeer's main interests were depicting clothed figures and still-life details, devising balanced compositions, and playing with light and colour.

The young Vermeer studied the work of others carefully. His *Diana and her Nymphs* seems to have been inspired, in particular, by Jacob van Loo (1614–1670), who was active in Amsterdam. Van Loo painted the bathing Diana and her companions a number of times. A painting he made in 1648 is clearly related to Vermeer's depiction, both in its composition and in the poses of the figures, who are likewise dressed (fig. 13). In Van Loo's painting, the sitting, partly overlapping figures are placed along a diagonal, which draws the viewer's gaze ever deeper into the picture. Vermeer employed the same device for the two seated women and the woman standing at the back on the right. Diana's pose — sitting with one leg outstretched and leaning on one arm — also corresponds to some degree. Vermeer seems to have taken the poses of the two nymphs on the left in Van Loo's picture — one removes her shoe and the other touches her foot — and combined them in the crouching figure to the right of Diana (fig. 14a–b).[27]

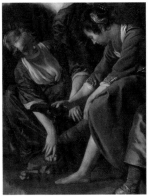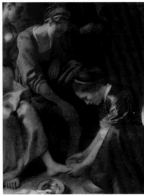

14a Jacob van Loo, *Diana and her Nymphs*: detail.
14b Johannes Vermeer, *Diana and her Nymphs*: detail.

The atmosphere of carefree enjoyment in Van Loo's painting is entirely different, however, from the calm, subdued mood in Vermeer. If, in fact, he had seen Jacob van Loo's painting or a similar example, he adopted it freely, in a way all his own. The same holds true for other possible sources of inspiration that have been suggested, including Rembrandt, Rubens and Titian.[28] Art historians have frequently pointed out the Italian influences in *Diana and her Nymphs*, especially the glowing colours reminiscent of the Venetian school.[29] There is nothing, however, to indicate that Vermeer ever visited Italy himself. He might have come into contact with Italian art through painters who had been there (see pp. 35, 38), but certainly also by studying the Italian paintings to be seen in Holland. In any case, towards the end of his life, Vermeer was considered an expert on Italian painting, for in 1672 he was asked to give his opinion of a dozen paintings which, in his view, were wrongly thought to be the work of great Italian masters.[30]

Christ in the House of Martha and Mary

circa 1654–1655

Even more so than *Diana and her Nymphs*, the painting of *Christ in the House of Martha and Mary* (fig. 15) is surprising because of its size — it is Vermeer's largest known painting — and its bright, intense colours. It was not associated with Vermeer until 1901, when his signature was discovered at the lower left on the side of the foot-stool (see p. 81, fig. 49; see also pp. 58–63). The balanced composition shows three figures closely linked by their gestures and gaze. Mary, listening intently, sits at the front on a foot-stool; her eyes are firmly fixed on Christ, who points to her with his right hand while looking up at Martha, who is standing behind the table. Though her head is turned towards Christ, her eyes are lowered. It is this interaction that portrays the essence of the biblical story. The Gospel according to St Luke (10:38–42) relates that Christ, while travelling, was received in the house of a woman named Martha. While Martha was busy serving, her sister Mary sat at Christ's feet, listening to his every word. When Martha objected to this, Christ answered: 'Martha, Martha, thou art careful and troubled about many things: But one thing is needful: and Mary hath chosen that good part, which shall not be taken away from her'. These words are interpreted as an exhortation to place the spiritual above the material. By focusing on Christ's pointing hand and contrasting it with the white tablecloth, Vermeer underscored the moral of the story.

This choice of subject and the way it is portrayed have been connected with Vermeer's conversion to Catholicism, which probably took place shortly before his marriage on 20 April 1653.[31] Vermeer was a Protestant by birth, but the family of his wife, Catharina Bolnes, was Catholic. This could be why his mother-in-law, Maria Thins, refused to give her written consent to the marriage. However, according to the statement made by the two witnesses, one of whom was the painter Leonaert Bramer, she said repeatedly that she would not stand in the way of her daughter's marriage.[32] From this it has been inferred that Vermeer had meanwhile declared his intention to become a Catholic, although there is no written evidence to this effect.[33]

A painting as large as *Christ in the House of Martha and Mary* is unlikely to have been made for the free market. It was possibly intended for a clandestine church in Delft or for the drawing room of a Catholic patron, perhaps even Vermeer's mother-in-law. The subject, in any case, is not exclusively Catholic, and was also popular in Protestant circles from the sixteenth century onwards.[34] Painters frequently seized the opportunity presented by this biblical episode to illustrate all manner of food and cooking utensils (e.g. fig. 19). Vermeer, refraining from such excess, confined himself to a simple basket of bread. This draws all attention to the three main figures, placed within an imaginary triangle of which Martha forms the highest point. The interior, which is only sketchily rendered, includes a view to another room at the left rear, where a door stands ajar. Despite its large size and religious subject matter, the scene has a homely, everyday atmosphere, which is transcended only by Christ's halo.

Again Vermeer demonstrates his mastery in rendering the light falling on figures and objects. One of the loveliest details is Mary's inclined head: her shaded face stands out sharply against the white tablecloth, while her striped headscarf

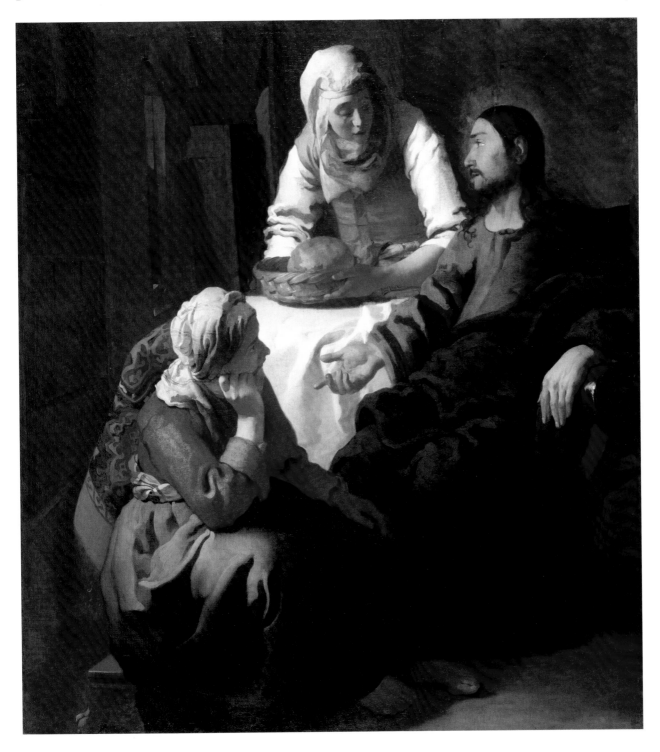

15 Johannes Vermeer, *Christ in the House of Martha and Mary*, c.1654–1655. Canvas, 160 × 142 cm. Edinburgh, National Gallery of Scotland (cat. no. 2).

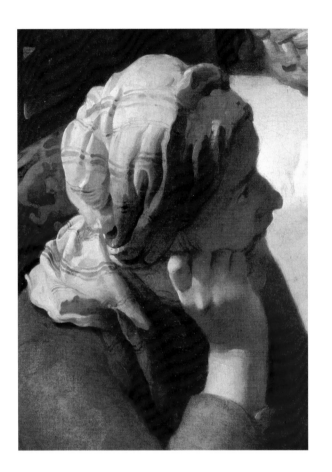

catches the light falling onto the scene from the left, thus enhancing the three-dimensional effect (fig. 16). The tip of the colourful rug beneath the table-cloth, which follows the contour of her back, is also convincingly rendered. This detail anticipates Vermeer's later interiors, in which such rugs often appear. Like *Diana and her Nymphs*, this work has some less successful passages. For example, the form of the table beneath its covering remains indistinct, and looks too narrow in comparison with the figure of Martha, who bends over it. Nor is there a clear connection between the figures and the background, which makes it seem as though the episode takes place in front of stage decor.

16 *Christ in the House of Martha and Mary*: detail of Mary's head.
17 a. *Christ in the House of Martha and Mary*: detail of Mary's feet.
 b. *Diana and her Nymphs*: detail of Diana's foot.

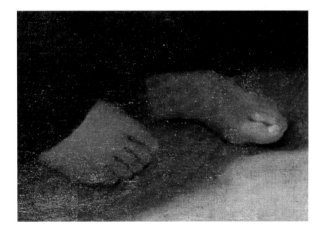

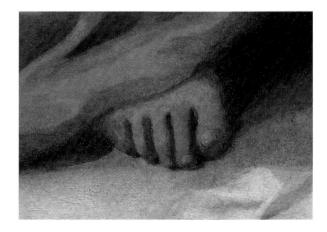

Vermeer executed this picture with unerring fluency, leaving the broad, flowing brushstrokes clearly visible in many places.[35] This is evident in the undulating lines of the bright passages in Martha's sleeves and Christ's cloak. The highlight on the armrest of the chair was applied with a vigorous brushstroke. In its broad brushwork, *Christ in the House of Martha and Mary* differs somewhat from *Diana and her Nymphs*, and shows that the young Vermeer was experimenting with various painting techniques. Even so, the two paintings are similar in some respects. The figures' clothes, for example, were painted in the same colours: ochre yellow, red, deep blue and violet. The characteristic rendering of their bare feet is also very similar (fig. 17a–b). The spotlighted hands of Christ, however, were painted in a much more refined way than the hands in *Diana and her Nymphs*, which implies a more advanced artist. While painting, Vermeer altered the position of the fingers of Christ's left hand. Changes were also made to his profile and his ear, as seen in the X-radiograph (fig. 18), but these details did not affect the composition as a whole.[36]

The composition of *Christ in the House of Martha and Mary* has often been compared with a painting of the same subject (fig. 19) by the Antwerp artist Erasmus Quellinus II (1607–1678).[37] There is, in fact, a striking similarity in the pose of the seated Christ and, to a slightly lesser extent, in the inclination of Mary's head, but this does not necessarily mean that Vermeer had actually seen the painting by Quellinus. The attitude of the Christ figure can also be found in works by other Flemish and even some Italian artists.[38] Moreover, in an engraving

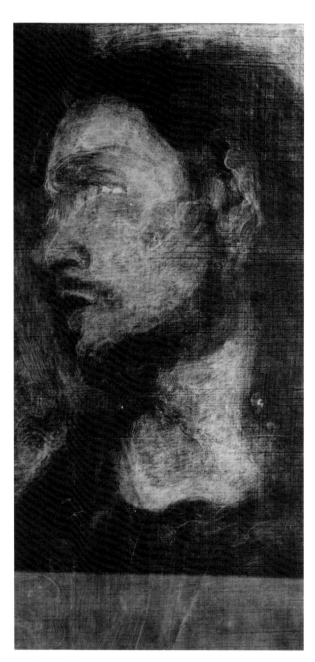

18 *Christ in the House of Martha and Mary*: detail of X-radiograph of Christ's head.

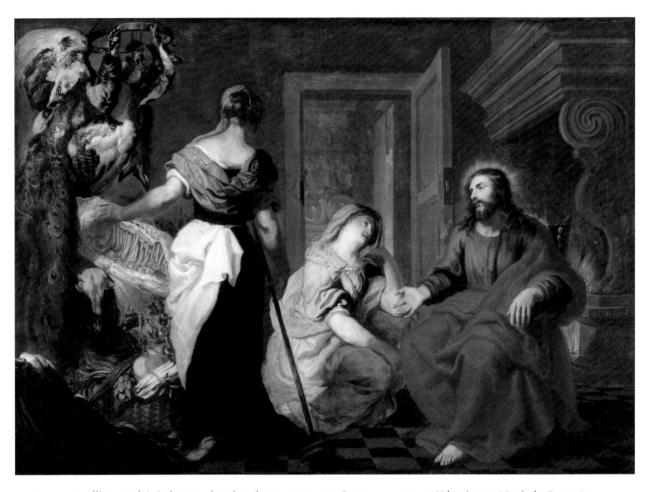

19 Erasmus Quellinus II, *Christ in the House of Martha and Mary*, c.1640–1645. Canvas, 172 × 243 cm. Valenciennes, Musée des Beaux-Arts.

20 Georg van de Velden after Otto van Veen, *Christ in the House of Martha and Mary*, c.1597. Engraving, 35.2 × 28.2 cm.

21 Hendrick ter Brugghen, *The Liberation of St Peter*, 1624. Canvas, 104.5 × 86.5 cm. The Hague, Mauritshuis.

by Georg van de Velden after a design by Otto van Veen (1556–1629), the three main figures are placed in a way comparable to the arrangement seen in Vermeer's composition (fig. 20). Thus it is difficult to pinpoint specific examples, but Vermeer was clearly aware of the pictorial tradition of this subject.

The style of painting suggests that Vermeer was possibly influenced by the work of the Flemish master Anthony van Dyck (1599–1641) and the Utrecht painter Hendrick ter Brugghen (1588–1629;

fig. 21).[39] The latter was one of the so-called Utrecht Caravaggisti: painters who had visited Italy, where they were so impressed by the work of Caravaggio (1571–1610) that they continued to paint in his style after their return to Holland. Ter Brugghen seems to have been the source of inspiration for Vermeer's subtle toying with light and dark, and the expressive gestures of his figures' hands. His familiarity with the work of the Utrecht Caravaggisti is even more clearly demonstrated by the third painting from his early career.

The Procuress

1656

Because *The Procuress* (fig. 23) bears Vermeer's signature and is dated 1656, it is certain that he painted it some three years after becoming a member of the Delft painters' guild.[40] Here, for the first time, Vermeer chose a subject that can be considered genre painting. The term 'genre piece' is used to denote a composition with human figures engaged in everyday activities (as opposed to the figures in history paintings). In *The Procuress*, a name given to this painting only at the end of the nineteenth century, a seated young woman wearing a yellow jacket immediately catches the viewer's eye. The glass of wine in her left hand is probably the cause of her flushed cheeks. She raises her other hand expectantly to take the coin offered to her by a

22 Jan Steen, *Woman Playing a Cittern*, c.1662. Panel, 31 × 27.5 cm. The Hague, Mauritshuis. .

young man, whose features are veiled in the shadow cast by his plumed, broad-brimmed hat. He bends over the young woman, and the bold, yet nonchalant, way in which he rests his hand on her breast is a clear statement of his intentions. They both look at the coin, and the viewer's eye, too, is drawn unavoidably to its glinting edge by the gold piping on the man's red sleeve. It is no coincidence that the act of handing over the money is the focal point of the composition, for there is no doubt that this is a business transaction: the man is paying the woman for sexual services soon to be rendered. What seems at first glance to be a cosy tête-à-tête is, in fact, a brothel scene. Next to the young couple hovers an older woman: the procuress, who has arranged this meeting and will pocket her share of the proceeds. Her staring eyes and the black cap enclosing her face lend her a strange, almost mask-like appearance.

The company is completed by the young man on the left. Raising his beer glass and wearing a broad grin on his face, he looks frankly at the viewer from beneath his beret (fig. 30a). Both his gaze and his position at the side identify him as the narrator who introduces us to this scene. His role as an outsider is also apparent from his attire: in 1656 his clothes had been outmoded for some time and seventeenth-century viewers would have seen them as old-fashioned, compared with the contemporary clothing of the young couple.[41] Extending upward from his right hand is the neck of a cittern: a plucked instrument frequently played by women in seventeenth-century paintings (fig. 22). This detail might be a phallic symbol, intended to underline the racy nature of the scene.[42] The man with the beret

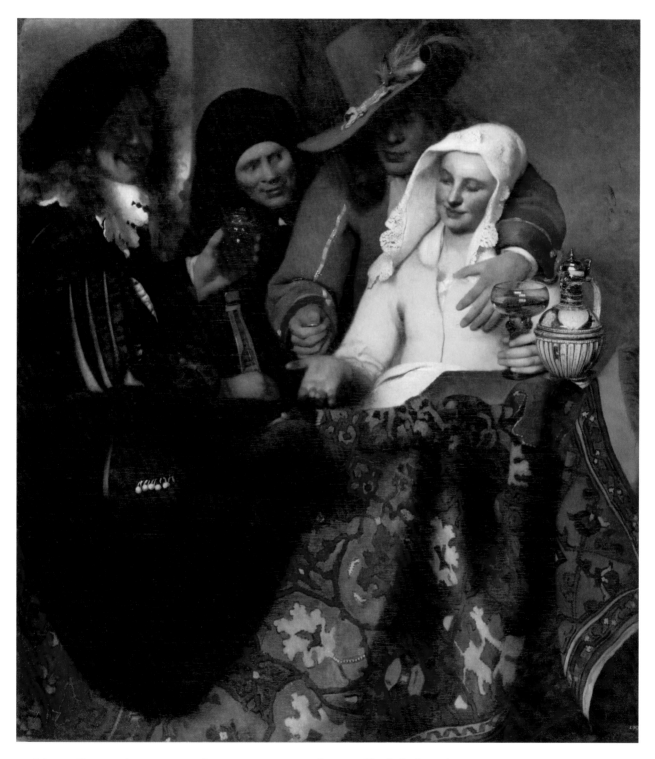

23 Johannes Vermeer, *The Procuress*, 1656. Canvas, 143 × 130 cm. Dresden, Gemäldegalerie Alte Meister,
 Staatliche Kunstsammlungen (cat. no. 3).

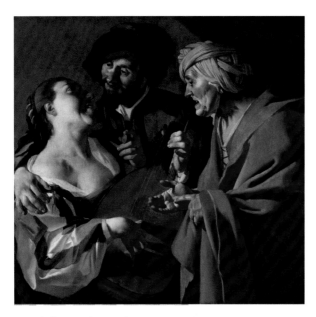

24 Dirck van Baburen, *The Procuress*, 1622. Canvas, 101 × 107 cm. Boston, Museum of Fine Arts, M. Theresa B. Hopkins Fund.

is the only figure who looks at us, and because it was not unusual for painters to cast themselves in the role of figurant in genre pieces of this kind, he might well be a self-portrait.[43] Unfortunately, we do not know what Vermeer looked like, but it is tempting to think that here we stand face to face with the painter himself.

Unlike the figures in the previous two works, these people are not portrayed full-length. The lower half of the painting is completely taken up by an Oriental rug and a fur coat draped over an invisible balustrade. Strikingly, the dominant colours in the young couple's clothing — yellow and red — recur in the pattern of the rug. The venue is unclear. The flat wall with the pillar and the view to the left rear might indicate that the scene is set on a balcony.[44] The spatial rendering of the composition, like that of *Christ in the House of Martha and Mary*, is not entirely convincing. It cannot be said with certainty, for instance, if the man on the left is sitting or standing.

In choosing the theme of the procuress, Vermeer was carrying on in the pictorial tradition popularised as early as the 1620s and 1630s by such Utrecht Caravaggisti as Dirck van Baburen (c.1594/95–1624), Gerard van Honthorst (1592–1656) and Jan van Bijlert (1597/98–1671). These artists produced numerous paintings, later euphemistically referred to as merry companies, which were actually brothel scenes. The theme had developed from sixteenth-century portrayals of the biblical parable of the Prodigal Son, who squandered his inheritance on 'harlots' (Luke 15:11–32).[45] It is certain that Vermeer knew at least one brothel scene by an Utrecht Caravaggist, for his mother-in-law, Maria Thins, in whose house he lived after marrying her daughter, owned 'a painting in which a procuress points into her hand'.[46] This painting is probably identical with a work by Dirck van Baburen of 1622 (fig. 24), which Vermeer depicted in the background of two of his interiors.[47] As in Vermeer's *Procuress*, the

25 Christiaen van Couwenbergh, *Brothel Scene*, 1626. Panel, 78 × 110 cm. Present whereabouts unknown.

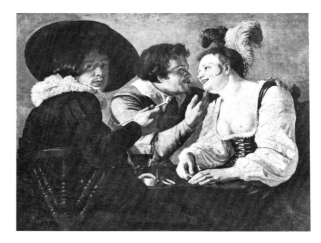

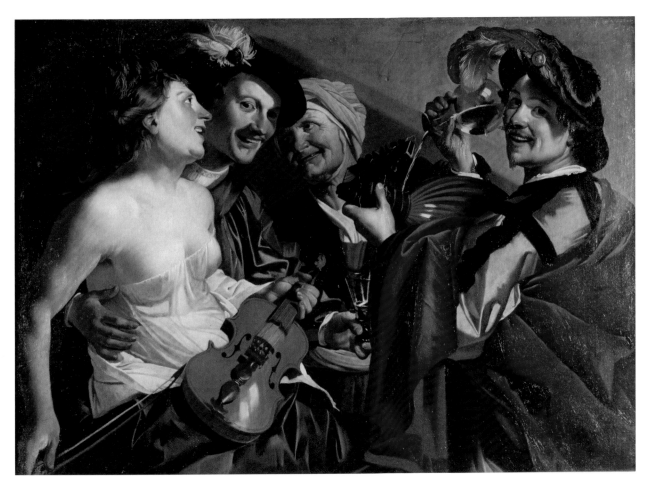

26 Dirck van Baburen, *The Procuress*, 1623. Canvas, 110 × 154 cm. Mainz, Landesmuseum.

theme of 'sexual favours for money' is expressed by handing over a coin. Van Baburen depicted the event in a typically Caravaggesque way, with strong light-dark contrasts and half-length figures that fit tightly into the picture plane. Another painting of this subject by the same artist displays a striking similarity to Vermeer's composition, but in reverse: on one side we see a young couple, the man embracing the woman, in the middle the procuress watching them, and on the other side a musician with a beret, laughing as he turns towards the viewer (fig. 26).[48]

The influence of the Caravaggisti on the young Vermeer led to the assumption that he received his artistic training in Utrecht (see also p. 23). Their brothel scenes, however, date from several decades before his presumed apprenticeship, so it seems more likely that he drew inspiration from some of their paintings, which he apparently had the occasion to study. In the 1620s, moreover, Christiaen van Couwenbergh (1604–1667) produced in Delft brothel scenes that were completely in keeping with the Caravaggesque movement, and these could also have served as Vermeer's example (fig. 25).[49]

Here, too, Vermeer assimilated his source of inspiration in an idiosyncratic way. X-radiographs of *The Procuress* (fig. 27) show that during the paint-

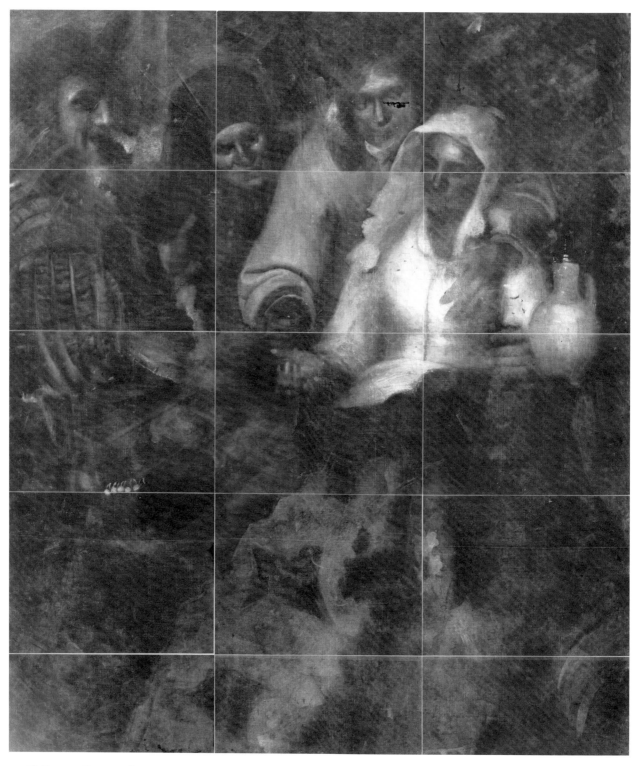

27 The Procuress: X-ray mosaic.

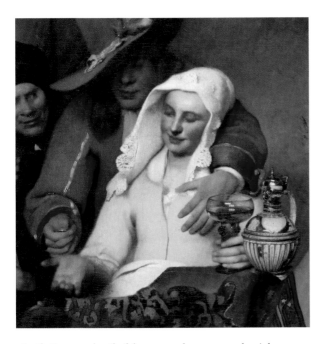

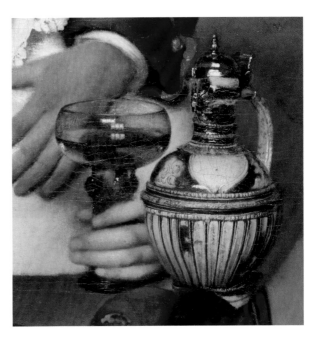

28 *The Procuress*: detail of the man and woman on the right.

29 *The Procuress*: detail of the young woman with a glass of wine and wine jug.

ing process he gradually distanced himself from the way the Caravaggisti had portrayed the subject.[50] Close comparison of the X-radiographs and the completed painting reveals that Vermeer made a couple of essential changes to the composition — something he did not do in the two previous works. The most striking adjustments are those made to the figure of the man wearing the red jacket: initially his face was not concealed in the shadow cast by his hat, and his gaze was directed at the young woman. The fact that in the finished painting his face is only partly visible and all attention is focused on the coin makes the transaction seem impersonal (fig. 28). Vermeer had originally depicted a second coin in the woman's open hand, but by painting it out he intensified the woman's expectant attitude, thus heightening

the dramatic tension. He also made several small changes to this figure: he moved her white cap upwards slightly to show more of her forehead, and adjusted the position of the fingers wrapped around the wineglass. In the painting a sixth fingertip is vaguely visible above this hand (fig. 29).

The X-radiograph reveals — to the left of the handover of the coin, above the hand holding the neck of the cittern — a light-coloured form that does not recur in the uppermost layer of paint. It is possible that Vermeer initially depicted the hand of the procuress here, to clarify her involvement in the transaction. In the end he decided to omit her hand, no doubt to draw more attention to her leering eyes. In the X-radiograph the beret of the young man on the left is considerably smaller, which allows the light falling from the left to

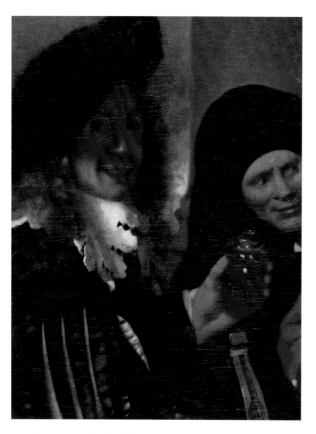

30a *The Procuress*: detail of the man and old woman on the left.

30b *The Procuress*: detail from the X-ray mosaic.

illuminate his face more brightly. In the finished painting, only his chin, the tip of his nose and his white collar catch the light, and his laughing mouth is mostly overshadowed (fig. 30a–b). During the painting process, changes were also made to the lower half of the picture: the pattern of the rug originally extended across the entire foreground; the dark jacket, which is draped over the rug on the left, was added later. This change is in keeping with the dark tones of the clothing of the figures on the left, and strengthens the contrast with the bright red and yellow hues on the right.

In short, it can be said that Vermeer's interventions made the figures and their actions less expressive and more subdued, when compared to their Caravaggesque examples (cf. figs. 24–26). And although he intensified the contrasts between the light and dark passages, he did so more subtly than the Caravaggisti. His feeling for the effects caused by the light falling diagonally into the room anticipates, yet again, his later work.

The recent conservation treatment of the canvas in 2002–2004 facilitated close examination of Vermeer's painting technique.[51] The brushwork

is mostly smooth, though in places the paint was applied thickly. This is the case, for example, in the lead-tin yellow of the woman's jacket, which surrounds the man's hand resting on her breast, his fingers seemingly pressing into the fabric. By contrast, the wine jug of Westerwald stoneware, standing to the right on the table, is very carefully painted, and Vermeer even took pains to depict its small imperfections (fig. 29). Technical research has shown that he used a compass to draw a circle in the wet paint in order to delineate as perfectly as possible the round shape of the jug.[52] The detailed depiction of this object makes it seem closer to the viewer than the wineglass behind it. Vermeer's fascination with the rendering of fabric is also evident in the rug and the coat in the foreground: the low viewpoint makes it seem as though we are standing right in front of them.

The 'Vermeer-like' Vermeer

The Procuress of 1656 heralds a new phase in Vermeer's artistic development. It still has some similarities to the two earlier paintings: its palette, for instance, is dominated by yellow and red tones, the background is indefinable, and the objects were depicted with great attention to detail, as was the basin in Diana and her Nymphs. The gaze of the young woman in The Procuress is comparable to Martha's lowered eyes in Christ in the House of Martha and Mary, but also points ahead to later work, such as The Milkmaid of around 1657–1658 (fig. 33). The most important step forward is the choice of a subject from everyday life instead of a mythological or biblical scene, though the association with the parable of the Prodigal Son is still evident (see p. 38). From this

time on, Vermeer began to specialise in interiors. We can only speculate about the exact reason for his switch from history to genre — whether this was a personal preference or the result of his clients' wishes. In any case, this change brought him in line with a trend evident in the 1650s. Pieter de Hooch (1629–in or after 1684), for instance, began to paint similar domestic scenes in Delft at about the same time.[53] Vermeer might also have been influenced by Gerard ter Borch, an artist known for his depictions of elegant companies, who was a personal acquaintance of Vermeer (see p. 23).

Vermeer's next known work, A Maid Asleep of around 1656–1657 (fig. 31), has only one figure, since a man in the adjoining room and a dog looking at him from the doorway were overpainted by Vermeer himself.[54] This reduced the anecdotal elements to a minimum and focused all attention on the serenity of the scene. With her closed eyes, the girl is reminiscent of the young woman in The Procuress, but her facial characteristics and her jacket recall those of the woman kneeling at the lower right in Diana and her Nymphs. The patterned rug is comparable to the one in Christ in the House of Martha and Mary, while the way in which the rug is caught up at the front produces the same effect seen in The Procuress. Apparently Vermeer had not lost sight of his earlier work, though he had clearly taken a new direction. A Maid Asleep was probably owned by Pieter Claesz van Ruijven (see p. 54). It is conceivable that the taste of this patron, who began to provide the painter with financial assistance as early as 1657, also influenced Vermeer's choice of subject and style of painting.

The Letter Reader of around 1657 is the first of his works to conjure up the Johannes Vermeer that we know today (fig. 32).[55] A young woman, immersed

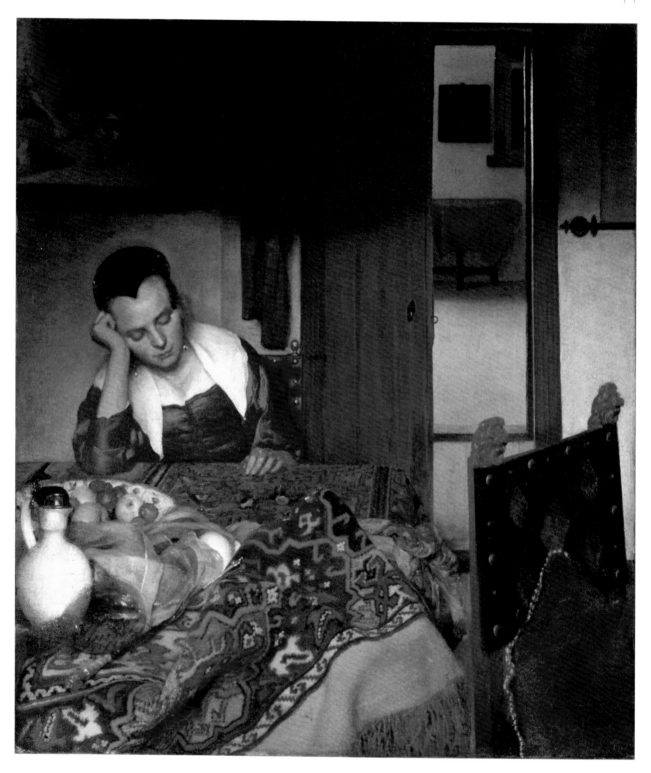

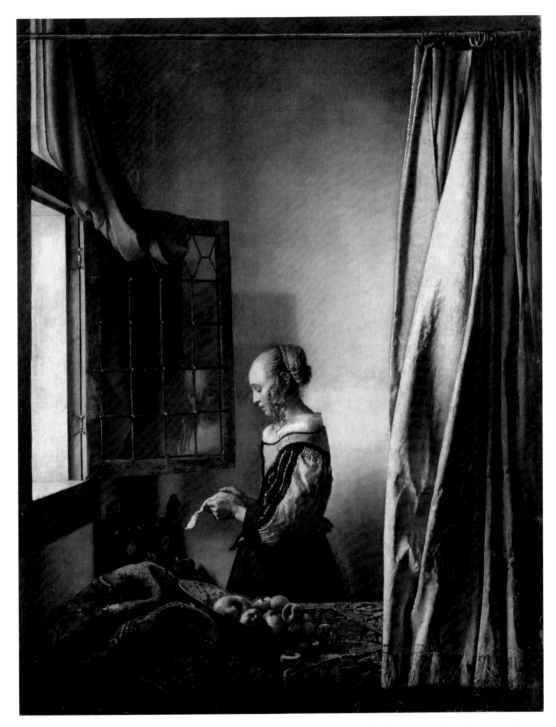

‹ 31 Johannes Vermeer, *A Maid Asleep*, c.1656–1657. Canvas, 87.6 × 76.5 cm. New York, The Metropolitan Museum of Art, Bequest of Benjamin Altman.

32 Johannes Vermeer, *The Letter Reader (Young Woman Reading a Letter)*, c.1657. Canvas, 83 × 64.5 cm. Dresden, Gemäldegalerie Alte Meister, Staatliche Kunstsammlungen.

in the letter she holds in her hands, stands in front of a bare wall in a room with little to distract our attention. Her face is reflected in the pane of the open window. The curtain pushed to one side and the table, which stands in the foreground like a barrier, create a sense of distance and give us the impression that we are witnessing an intimate moment. The apparent simplicity, the balanced composition and the woman's retiring nature recur in *The Milkmaid*, painted a short while later (fig. 33). At first glance, these and later paintings by Vermeer seem completely different from his three earliest works. This prompted Albert Blankert, who has devoted numerous publications to Vermeer, to make the apt statement that 'all the "Vermeer-like" Vermeers were not painted until after *The Procuress*, that is, after 1656'.[56]

What the early works do have in common with the paintings made after 1656 are their concentration on the main subject and the fact that outwardly perceptible emotions are kept to a minimum and inner feelings thus come to the fore. That these features emerged early on as the core of Vermeer's characteristic style is clearly shown by comparing his approach with the prevailing pictorial traditions. In *Diana and her Nymphs*, he declined to take advantage of the possibilities the subject offered to paint a scene of wild revelry or titillating nudes. The nymphs are introspective or engrossed in their activities. With their faces largely veiled in shadow and their eyes lowered, they make an aloof and inscrutable impression.

In *Christ in the House of Martha and Mary*, there is more interaction between the figures, but they likewise form a closed group. Unlike other artists who chose this subject, Vermeer omitted all accessories that were likely to detract from the crux of the story. The theme of *The Procuress* gave him the perfect opportunity to portray a scene of exuberance and vigour, yet here, too, he showed remarkable restraint, even taking pains, while painting, to introduce changes aimed at making the atmosphere more subdued.

Remarkably, Vermeer's first works show that he was avoiding as much as possible the depiction of action, emotions and a clear narrative line, even though these elements were among the most important ingredients of history painting. He must have discovered early in his career that his strength as a painter lay more in stillness than in movement. This prompted him to choose other subjects, such as interiors, in which he could make better use of his talent. Nevertheless, his early works already betray a number of specific characteristics that recur in his later paintings, such as his preference for bright colours and balanced compositions, a keen interest in rendering materials, and his complete command of lighting effects. Although *Diana and her Nymphs*, *Christ in the House of Martha and Mary* and *The Procuress* plainly differ from his more mature work, they already contain the seeds of his development and clearly show that there is something 'Vermeer-like' even in the earliest Vermeers.

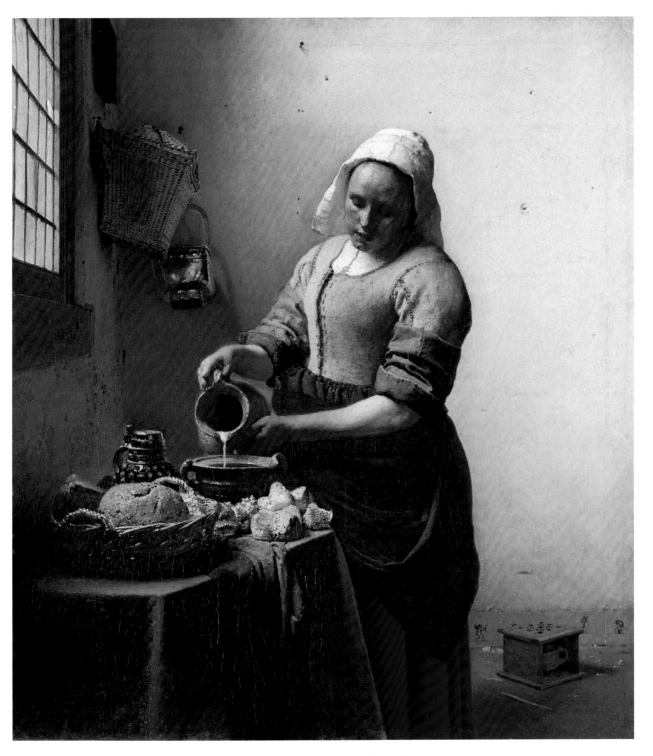

33 Johannes Vermeer, *The Milkmaid*, c.1657–1658. Canvas, 45.4 × 40.6 cm. Amsterdam, Rijksmuseum.

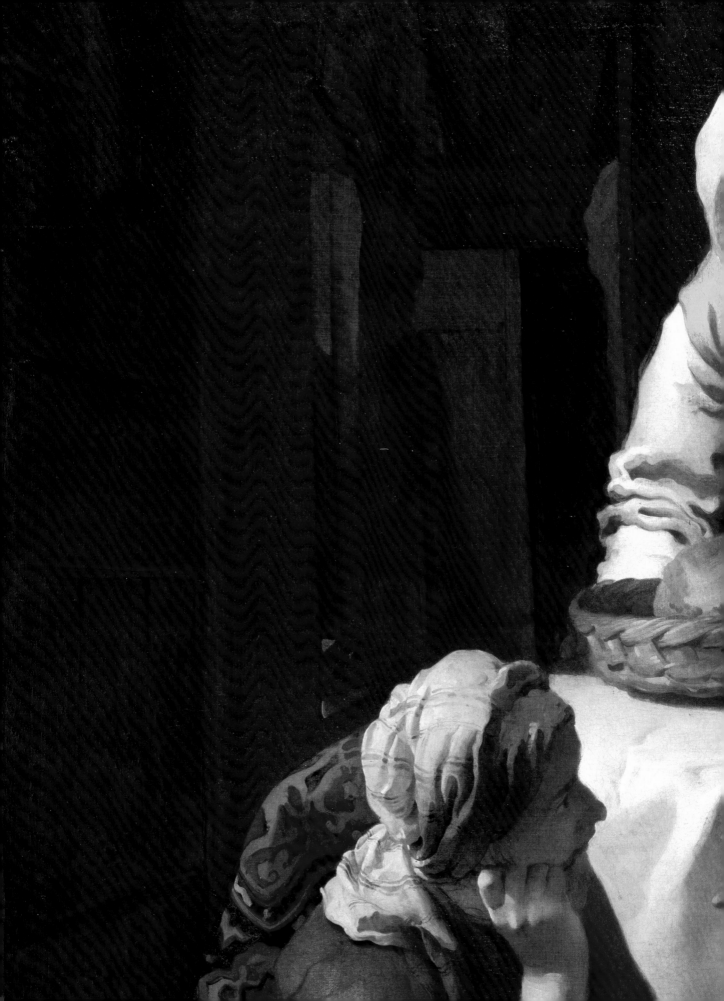

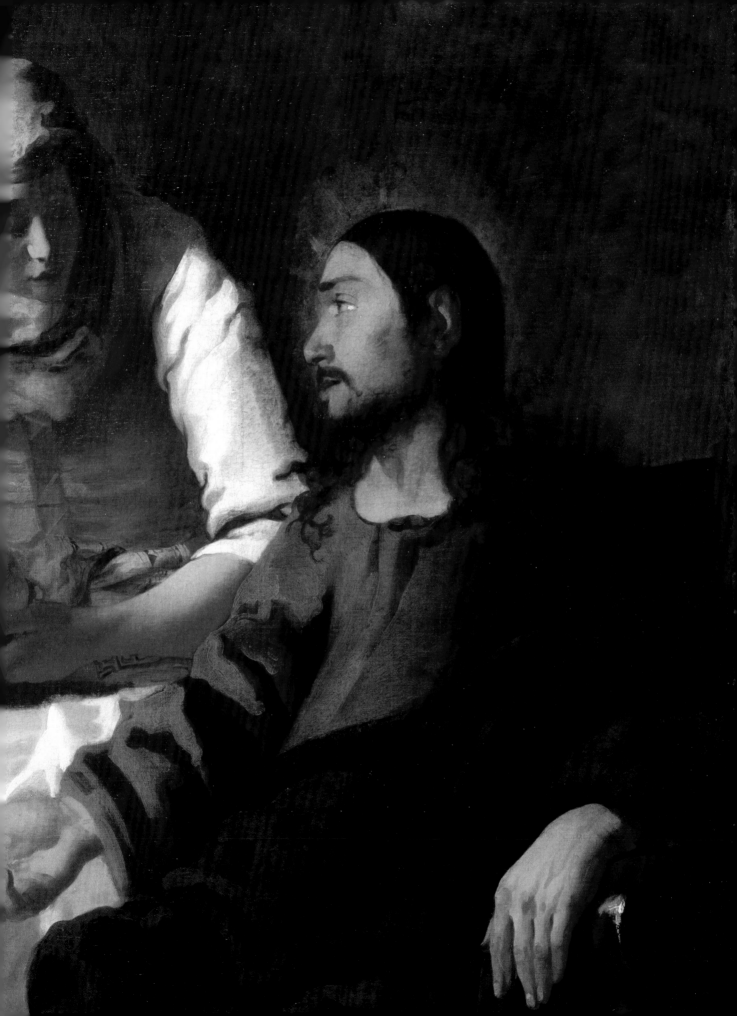

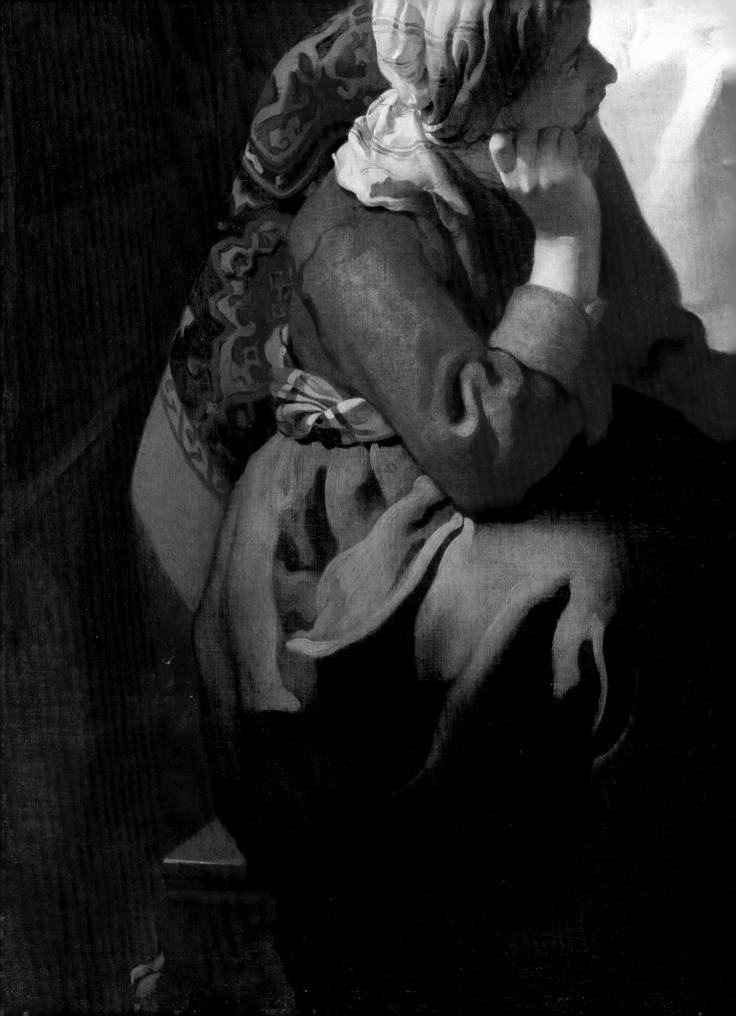

The Rediscovery of the 'Young Vermeer'

Edwin Buijsen

During his lifetime, Johannes Vermeer was known only to a small circle of devotees.[57] The Delft rentier and art lover Pieter Claesz van Ruijven (1624–1674) owned no fewer than 21 paintings by his hand, and can therefore be considered his patron.[58] Other people in Delft also owned one or more paintings by Vermeer. His reputation did extend beyond the city limits, however, for in 1663 he was paid a visit by the French diplomat Balthasar de Monconys (1611–1665), whose attention had probably been drawn to Vermeer by Constantijn Huygens (1596–1687), the influential secretary

34 *Étienne Joseph Théophile Thoré, alias Thoré-Bürger* (photograph from the sale catalogue of the Thoré-Bürger Collection, Paris, 5 December 1892).

to the stadholder. Even so, Vermeer never attained the level of fame such masters as Rembrandt and Frans van Mieris enjoyed in their lifetime. After Vermeer's death in 1675 and the dispersion of Pieter van Ruijven's collection, which was sold at auction in 1696 as part of his son-in-law's estate, the painter's name was quickly forgotten. In the eighteenth century, his works were often attributed to such artists as Pieter de Hooch and Frans van Mieris, who in those days were more widely known.

Thoré-Bürger and his 'sphinx'

In the nineteenth century, Vermeer attracted interest again, among other reasons because in 1822 the Dutch state bought *View of Delft* (fig. 35), probably once part of Van Ruijven's collection, at an auction in Amsterdam for 2,900 guilders. King Willem I, who made funds available for this purchase, intended the painting for the Mauritshuis. It thus became the first Vermeer in a Dutch public collection. The decision to make this purchase was no doubt based on the high quality of the work and its subject matter, rather than the reputation of its maker, who was then hardly known. Even though Vermeer attracted the attention of a few art connoisseurs in the first half of the nineteenth century, the Frenchman Étienne Joseph Théophile Thoré (1807–1869) was the first to undertake an in-depth study of the artist, in the second half of the century.[59] He was thus of great importance in furthering the international appreciation of the 'sphinx', the nickname he gave this mysterious artist, about whom he knew so little. For political reasons, Thoré published under the name of William Bürger, which is why he is known in the art-historical literature as 'Thoré-Bürger' (fig. 34).

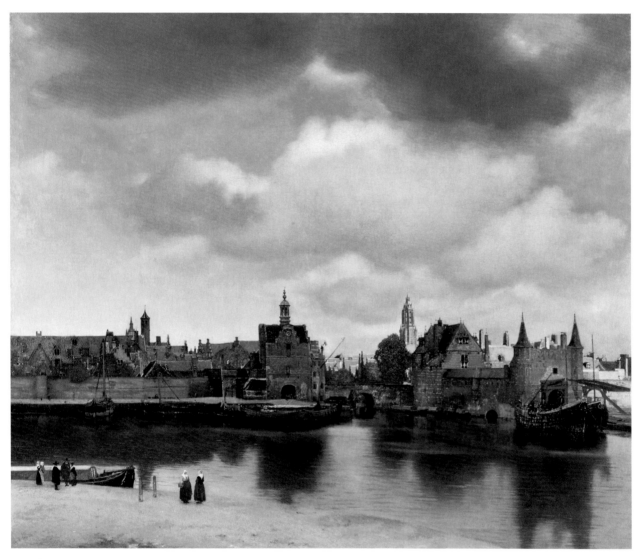

35 Johannes Vermeer, *View of Delft*, c.1660–1661. Canvas, 96.5 × 115.7 cm. The Hague, Mauritshuis.

36 *Victor de Stuers.*

In the first volume of his *Musées de la Hollande* of 1858, Thoré-Bürger devoted only a few pages to the 'Delft van der Meer'. He expressed admiration for the *View of Delft* which he had seen at the Mauritshuis back in 1842 — his first encounter with the painter's work.[60] In 1858 he described Vermeer as one of the 'unknown luminaries' ('illustres inconnus'), but two years later, in the next volume of *Musées de la Hollande*, he was able to add several more pieces of information, which he had gleaned from various sources. He also reported that during his travels he had discovered a number of 'new' Vermeers, mostly works previously assigned to other artists. In 1859, for instance, he travelled to Dresden to see with his own eyes *The Letter Reader*

(fig. 32). This painting was attributed to Pieter de Hooch, but it had been suggested that its real author was Vermeer of Delft. Thoré-Bürger not only confirmed this, but also discovered, during a visit to the museum in Dresden, another Vermeer: *The Procuress*. Even though this canvas was hanging high up on the wall, Thoré-Bürger could discern a great deal from his much lower position: 'The intensity and harmoniousness of the colours, the naturalness of the poses, the mood of the facial expressions, the power and peculiarities of the effects — all this points to Jan van der Meer of Delft.'[61] After climbing up a ladder to get a better look, he recognised Vermeer's signature in the lower right-hand corner and the date 1656 (see p. 81, fig. 50). Thoré-Bürger, who knew that Vermeer was born in 1632, realised that this was the first appearance of an early work. He was delighted to report that the mystery of the 'sphinx' was beginning to unravel.

In 1866 Thoré-Bürger recorded his knowledge of Vermeer in a series of articles that appeared in the authoritative journal *Gazette des Beaux-Arts*.[62] The oeuvre he had identified comprised more than 70 works, though many of these have since been rejected. He included a number of landscapes, for example, by Vermeer's namesake Jan Vermeer of Haarlem (see pp. 74–75), as well as several town-scapes that later proved to be the work of Jacob Vrel (active 1654–1662). In the introduction he described his quest as a 'persistent obsession' ('manie persévérante'). Thoré-Bürger's detective work and unflagging enthusiasm established his reputation as the rediscoverer of Vermeer. He was well aware, however, that the 'sphinx' had not yet revealed all his secrets, and expressed the hope that scholars around the world would go in search

of still-unknown paintings and report their findings to him. Unfortunately, Thoré-Bürger died only three years later, so he did not witness the discoveries made in the following decades that shed new light on Vermeer's early career.

The Delft or Utrecht Vermeer?

On 4 May 1876, *Diana and her Nymphs* was acquired by the Dutch state at a Paris auction for 10,000 French francs. It was intended for the Mauritshuis.[63] The canvas, at the time considered the work of Nicolaes Maes on the basis of a signature, had for a decade been in the possession of the director of the Hague gas-works, Neville Davison Goldsmid (1814–1875). The person responsible for purchasing the canvas at the Paris sale was Victor de Stuers (1843–1916), arts adviser at the Ministry of Internal Affairs (fig. 36). The then director of the Maurits-huis, Jan Karel de Jonge (1828–1880), had not been consulted. He was rather unenthusiastic about the acquisition of the painting, whose poor condition led him to believe that the price was much too high. In 1885 Maes's signature proved a forgery — vaguely visible beneath it was the original signa-ture of *JVMeer* (see p. 80, fig. 48a–d) — and this was reason enough to re-attribute the painting and assign it for the first time to Johannes Vermeer of Delft.

In 1892, when the signature was again examined — at the request of Abraham Bredius (1855–1946; fig. 37), who had taken up the post of director three years earlier — it was confirmed that 'the genuine signature was that of a Vermeer or Van der Meer', and the forged Maes signature was subsequently removed. Bredius had doubts, however, about the attribution of the painting to the Delft Vermeer: 'Its handling is completely different'. Because he

37 *Abraham Bredius.*

had detected what he thought was an obvious 'Italian influence', Bredius considered *Diana and her Nymphs* a work by the 'extremely rare Utrecht painter Jan van der Meer', who, unlike his Delft namesake, had actually spent some time in Italy.[64] In making this attribution, Bredius was apparently untroubled by the complete lack of comparable works by this Utrecht Vermeer or Van der Meer (see also pp. 74–75).

Other experts disagreed, however. In 1895 Jan Veth (1864–1924) and Cornelis Gerardus 't Hooft

De nieuw ontdekte Vermeer (?).

Onze correspondent te Londen schrijft ons d.d. Vrijdag-avond : *10 Mrt 1901 N Rot.*

Bij de kunstfirma Forbes and Paterson in Old Bond Street zal van Maandag e. k. af te bezichtigen wezen een groote schilderij, welke, volgens haar en ook volgens deskundigen hier te lande (Engeland) niet alleen is een echte Jan Vermeer van Delft, maar ook een zeldzaam, inderdaad een éénig doek van dien grooten meester met zulk een onderwerp : een groep van Christus, Maria en Martha. Heden werd ik, met andere persmannen, in de gelegenheid gesteld de schilderij in oogenschouw te nemen.

Haar geschiedenis is, laat mij dat eerst melden, kort en merkwaardig. Voor ongeveer anderhalf jaar overleed ergens op een landgoed buiten Londen een Engelsche dame, die het doek, met andere schilderijen, vele jaren geleden had gekocht, maar niet als een Jan Vermeer, veeleer, omdat de schoone vormen der figuren, de treffende lichtschakeeringen en het prachtige coloriet, bovenal in de kleedij der twee vrouwen, haar oog en smaak streelden.

Doch na haar dood kwam ook deze schilderij in veiling, en het werd bemachtigd door een kunstkenner, die er een onbekende Jan Vermeer in meende te herkennen. Hij bood het stuk toen der firma Forbes and Paterson aan, welke het van hem overnam, maar naderhand weer aan een anderen liefhebber te Londen verkocht. Laatstgenoemde is de huidige eigenaar en heeft geen plan de schilderij van de hand te doen.

Ziedaar de weinige bizonderheden, welke ik te weten ben gekomen, en mij werd erbij verzekerd, dat alle pogingen om méér van de geschiedenis dezer schilderij te vernemen of uit te vinden vooralsnog zonder gevolg zijn gebleven.

De heer D. S. Mac Coll, die een belangwekkend bericht nopens haar en nopens de weinige bizonderheden aangaande Vermeer bekend, voor de firma Forbes and Paterson heeft geschreven, moet erkennen, dat een studie der beschikbare bronnen geen uitsluitsel geeft betreffende een doek, welks manier ten eenenmale afwijkt van den gewonen stijl des meesters bij de erkend echte Vermeers in openbare of particuliere verzamelingen aanwezig. De genoemde deskundige ziet zich dan ook genoopt om zijn oordeel : dat wij hier een echte Jan Vermeer van Delft hebben, bijkans uitsluitend te gronden op de overeenstemmende teekening in deze schilderij en in de bekende Vermeer te Dresden.

Het is jammer, dat Dr. Bredius, toen hij onlangs hier was, geen gelegenheid gehad heeft om deze nieuw ontdekte Vermeer te zien. Aan z ij n oordeel over de echtheid zou natuurlijk zeer veel gelegen zijn.

38 Headline of the article 'De nieuw ontdekte Vermeer' ('The newly discovered Vermeer') in the *Nieuwe Rotterdamsche Courant* of 11 March 1901.

(1866–1936) reacted jointly in *De Kroniek*: 'Only a single painting by this Utrecht Van der Meer is known [see fig. 46], and not only does it lack a signature (so that the signature on the Hague painting by no means points to this painter), but its smooth, impotent style of painting and carbon-black palette do not bear the slightest resemblance to the robustly painted and brightly coloured Diana'. Both authors were convinced that this was an early work by the Delft Vermeer, painted under the influence of Carel Fabritius, whom they took to be Vermeer's teacher. In both subject and composition there was, admittedly, little to see of the 'later Vermeer-ness', but 'the whole of the remarkably bright palette, with his yellow, blue, orange and red, so strongly recalls the colour combinations later pursued by the painter, in ever finer handling, that on the grounds of this striking palette alone, it is permissible to attribute the Diana of the Mauritshuis to the Delft Vermeer'.[65] The Mauritshuis catalogue of 1897, though it maintained the attribution to the Utrecht Vermeer, did concede a note of doubt: 'It is not at all certain that this work is by the Utrecht Vermeer'.[66] In the spring of 1901, this issue took a decisive turn when another history painting with a similar signature surfaced on the London art market.

A 'newly discovered Vermeer' in London

On 11 March 1901, the London correspondent of the *Nieuwe Rotterdamsche Courant* (NRC) reported that a 'newly discovered Vermeer' would be shown a few days later at Forbes & Paterson's (fig. 38).[67] In the Netherlands this quickly became a matter of national importance. The journalist, who had attended a private viewing, was clearly

impressed by *Christ in the House of Martha and Mary*. Not only did English experts consider this canvas 'a genuine Jan Vermeer of Delft', but the work portrayed a biblical subject, which was unique in the master's oeuvre. With regard to its provenance, the journalist could only say that it had hung for years, unnoticed, in the country house of an English lady. After cleaning, the canvas proved to bear the signature of Vermeer (see p. 81, fig. 49). To broadcast this surprising discovery, art dealer Forbes & Paterson published a booklet by Dugald Sutherland MacColl (1859–1948), a Scottish water-colourist and art critic who later became the director of London's Tate Gallery and subsequently the Wallace Collection (fig. 39).[68] MacColl stressed the special character of *Christ in the House of Martha and Mary*, whose format and manner of painting he considered comparable only to *The Procuress* in Dresden. Because the latter work dates from 1656, he placed the newly discovered painting in the master's early period. That the two pictures were the work of the same artist was confirmed, in his opinion, by the strong similarity of the signatures. Remarkably, *Diana and her Nymphs* in the Maurits-huis was not taken into account, but it was not long before the Hague painting also became involved in the discussion surrounding the young Vermeer.

At the end of his article of 11 March, the NRC correspondent lamented the fact that Bredius had not yet seen the newly discovered Vermeer: 'A lot would depend, of course, on his opinion as to its authenticity'. On 26 March the same correspondent reported from London that 'the sudden appearance of this painting in our art circles has aroused exceptional interest', and that 'the experts here who believe in the authenticity of the canvas are steadily

A NOTE ON

VERMEER OF DELFT

AND THE PICTURE

" Christ with Martha and Mary."

THE discovery of an important picture, in first-rate condition, by Vermeer of Delft, would in any case excite attention. But the picture now on view at Messrs. Forbes and Paterson's differs in scale and treatment from all but one of his known works, and in subject is quite unexampled. The grasp shown here on the scale of life, and the easy control of the material in effects proper to that scale, explain how it is that the 'Little Master' was always, in little, big.

Jan Vermeer of Delft, by some accident, did not become securely fixed in the legend of his time, and suffered literary eclipse in the century following. Houbraken, the 'Dutch Vasari,' writing in 1719, does not cite his name, and the omission affected the accounts

5

39 Page from D.S. MacColl, *A note on Vermeer of Delft and the picture 'Christ with Martha & Mary'*, London 1901.

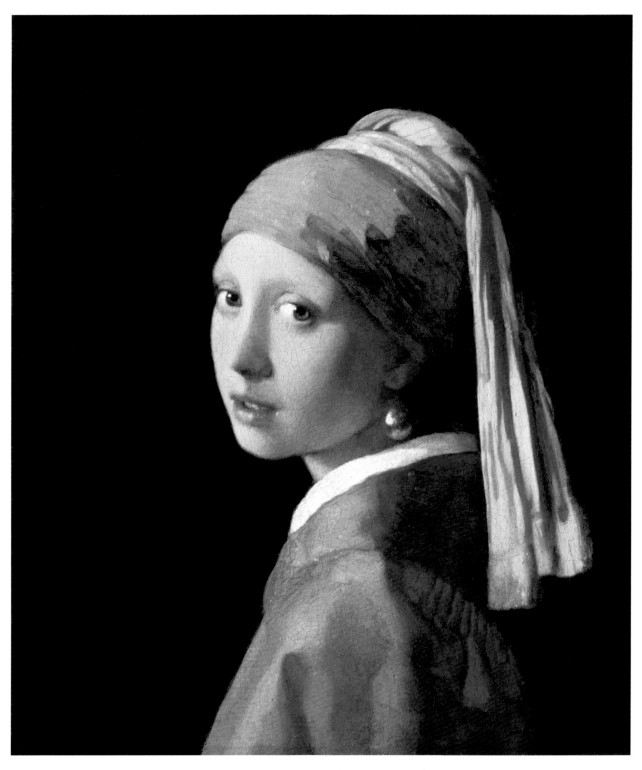

40 Johannes Vermeer, *Girl with a Pearl Earring*, c.1665. Canvas, 44.5 × 39 cm. The Hague, Mauritshuis.

growing in number'.[69] The English were waiting impatiently for the arrival of Bredius, who had meanwhile heard the news. On 28 March, the *Dagblad van Zuid-Holland en 's-Gravenhage* published an interview with the director of the Mauritshuis. This had taken place shortly before in the Vermeer Room of the museum, where one could admire both the *View of Delft* and the *Girl with a Pearl Earring* (fig. 40), the latter having been on loan to the museum since 1881. Although Bredius was excited about the news from London, he also had his doubts. The newly discovered picture was, after all, a history painting, as was 'his' *Diana and her Nymphs*, which was also in the Vermeer Room. And because he still attributed that painting to the Utrecht Vermeer, he remained sceptical. Comparison of the two works could, he thought, lead to a very different conclusion: 'If only we could manage to have the London work here on loan for a time, a comparison would perhaps result in a conclusion of importance to art history'.[70]

Bredius did not wait for this to happen, but decided to go to London himself. When the interview appeared in the *Dagblad van Zuid-Holland en 's-Gravenhage*, it was already old news. The paper therefore added a summary of a letter to the editor that had appeared in the NRC the previous day (27 March), titled 'De nieuwe Delftsche (?) Vermeer te Londen', in which Bredius had given a detailed account of his first-hand findings. He had confirmed with his own eyes that *Christ in the House of Martha and Mary* was 'without a doubt' by the same hand as *Diana and her Nymphs*: 'The same gamut of colours, the same broad, forceful brushwork, the same play of light and dark, not Rembrandtesque and yet so beautiful'. Bredius had also seen that the signatures were similar, and he was deeply

impressed by the quality of the piece in London: 'Everything is painted with virtuosity, not at all the work of a beginner'. He was not completely convinced, however, because he knew of 'no painting by the Delft Vermeer that resembled this piece as regards handling, colour and so on'. Only *The Procuress* in Dresden was somewhat similar in terms of colour. This brought Bredius to the following conclusion: both paintings — *Diana and her Nymphs* and *Christ in the House of Martha and Mary* — were unmistakably by the same hand, but he was not sure whether it was the hand of the Delft or the Utrecht Vermeer. In the former case, they belonged to a period in which Vermeer of Delft was painting in a style that differed from his other work and was influenced by Italian art; in the latter case, Vermeer of Utrecht would have to be counted among the best painters of the Dutch Golden Age — but why, then, had so little of his work survived?[71] Bredius's travel notes also betray how difficult it was for him to let go of his belief in the Utrecht Vermeer's authorship: 'Could they both be by the Utrecht Vermeer after all?' (fig. 41).[72]

In both paintings Bredius missed the 'idiosyncratic "pointillé" work' — the stipple technique he considered Vermeer's trademark — which was so clearly visible in the *View of Delft*. He regretted that he could not remember whether this 'pointillé' was also lacking in *The Procuress*. In the NRC of 29 March, Bredius reported that the director of the Dresden museum had told him that no trace of 'pointillé' could be seen in his painting either. The rug covering the table, moreover, displayed the same colours as the rug in the London painting, which prompted Bredius to conclude: 'So is it a DELFT Vermeer after all?'[73] Obviously he had not yet made up his mind. His new deputy director,

41 *Travel notes of Abraham Bredius*, March 1901.
 The Hague, Mauritshuis (documentation archives).
▸ 42 *Wilhelm Martin.*
▸ 43 Reyer Jacobsz van Blommendael (formerly attributed
 to Johannes Vermeer), *Diana and her Nymphs*. Canvas,
 122.5 × 162.4 cm. Present whereabouts unknown
 (photograph from *The Burlington Magazine* 1911).

Wilhelm Martin (1876–1954; fig. 42), who was in
London at the same time, was less hesitant. In
his notebook he wrote: 'Saw *Vermeer* at *Forbes*. [...]
The same colours occur in "Diana" in The Hague.

Verdict: the same hand as Diana, as well as
Dresden. Cf. table coverings!'[74] Martin brought
home from London a reproduction of the 'new
Delft Vermeer', which was put on display in the
'print stand' at the Mauritshuis so that those
interested could take note of it.[75] In the annual
report of the Mauritshuis for the year 1901 (which
was published in 1903), it appeared that Bredius's
doubts, too, had vanished. The director declared
that, as far as the painting of *Diana and her Nymphs*
was concerned, it could 'now be said with certainty
that it was painted by *Jan Vermeer of Delft*', because

it was by the same hand as *Christ in the House of Martha and Mary*.[76] The latter work had meanwhile been sold to the Scottish collector William Allan Coats (1853–1926), whose sons would donate it in 1927 to the National Gallery of Scotland in Edinburgh.

In the spring of 1901, the 'young Vermeer' took on a more distinct shape and character. It was not long before *Diana and her Nymphs, Christ in the House of Martha and Mary* and *The Procuress* were mentioned in the same breath as the early work of Johannes Vermeer of Delft, in which his exceptional talent first began to emerge.[77] Since that time, these paintings have belonged to the very heart of his oeuvre, despite the occasional objection to the two history paintings. In 1950 Pieter Swillens (1890–1963) even dared to reject their attribution

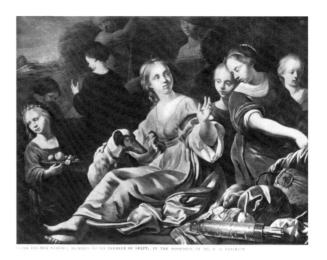

to Vermeer. He suggested Vermeer's father, Reynier Jansz, as the author of *Diana and her Nymphs*, and again put forward the Utrecht Vermeer as the maker of the painting in Edinburgh.[78] His views did not find favour with later writers, however, and nowadays the status of the three early Vermeers is seldom disputed.[79]

Quest

Once the idea had taken hold that Johannes Vermeer had started out as a history painter, the hunt was on for similar early works. In 1911 the English artist and art critic Roger Fry (1866–1934) published in *The Burlington Magazine* another painting portraying *Diana and her Nymphs* (fig. 43), which in his opinion bore all the characteristics of the young Vermeer and could well be by his hand.[80] The Dutch art historian Cornelis Hofstede de Groot (1863–1930), who saw the canvas that same year in London, was not convinced, but he expressed his doubts diplomatically, saying that, 'strictly speaking, there is nothing that makes this absolutely impossible'.[81] Nowadays the painting is

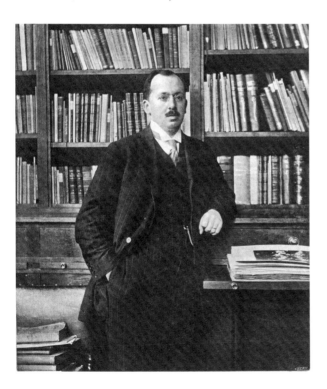

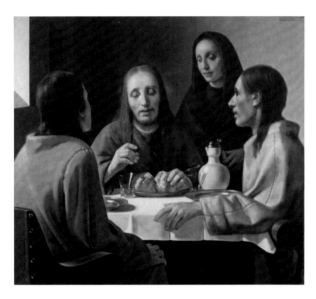

44 Han van Meegeren, *The Supper at Emmaus*, 1936–1937.
 Canvas, 117 × 129 cm. Rotterdam, Stichting Museum
 Boijmans Van Beuningen.

it as a Vermeer [...] I experienced nothing like the overwhelming feeling I had when the box containing the Supper at Emmaus was opened'.[85] Bredius considered it Vermeer's 'greatest masterpiece', and thought it had been painted not long after *Christ in the House of Martha and Mary*. It was purchased in 1938, with the assistance of the Rembrandt Society, for 520,000 guilders on behalf of the Boijmans Museum in Rotterdam, which did not yet have a work by the master in its collection.[86] There the new Vermeer soon attracted a lot of attention, and numerous connoisseurs heaped praise on it.[87] Within a short time, five more early Vermeers appeared on the market, all of them depicting religious subjects. After the Second World War, it became known that these five works, as well as the highly praised *Supper at Emmaus*, were forgeries produced by the painter Han van Meegeren (1889–1947) in the period 1936–1943.[88] The phrase 'just as it left the painter's studio', which Bredius had used in 1937 to describe the pristine condition of *The Supper at Emmaus*, thus took on an entirely different meaning.

One may well ask why the deceit went undetected for so long. To be sure, Van Meegeren had cleverly capitalised on the great desire of art historians to find the missing link between Vermeer's early and mature work. The yearning for a new Vermeer was apparently so great that one was prepared to ignore the defects in the execution of *The Supper at Emmaus*, such as the improbable folds in the sleeve of the man on the right. Moreover, the discovery in 1901 of *Christ in the House of Martha and Mary* had paved the way for the acceptance of atypical works. In those days one had an almost unconditional faith in the eye of the connoisseur, and it was not yet considered necessary to do extensive research into a

attributed to the little-known Haarlem painter Reyer Jacobsz van Blommendael (1628–1675).[82] The fact that it was once connected with Vermeer is some measure of the dogged determination that propelled the search for unknown early works by the master from the beginning of the twentieth century onwards.[83]

This quest reached a high point in November 1937, when none other than Abraham Bredius published in *The Burlington Magazine* a completely unknown work by the young Vermeer: *The Supper at Emmaus* (fig. 44).[84] In an article in *Oud Holland* published several months later, the 'grand old man' of Dutch art history, who was then 82, gave an enthusiastic description of the excitement he had felt at this discovery: 'In 1901, when I saw Vermeer's "Jesus at Mary and Martha's" in the window of a London art dealer's and recognised

45 Photograph of the first room of the exhibition *Johannes Vermeer* in the Mauritshuis, 1996, with *St Praxedis* in the middle.

work's provenance or to subject it to thorough technical examination.

The unmasking of Vermeer's 'greatest master-piece' as a forgery and the accompanying loss of face of art-historical scholarship sent shock waves through the art world, and subsequent discoveries were greeted with scepticism rather than approval. The search for unknown early works continued unabated, however, and was no doubt fuelled by Vermeer's ever-increasing fame.[89] Dirk Hannema (1895–1984), in particular, made frantic efforts to expand the painter's oeuvre. As director of the Boijmans Museum, Hannema had played a key role in the acquisition of *The Supper at Emmaus*, and he

had never accepted that it was a forgery. After withdrawing in the 1950s to Het Nijenhuis Castle in Heino, where his own art collection was housed, Hannema continued his search for new Vermeers. In 1972 and 1978 he published seven 'discoveries', including three early works, all of which belonged to his own collection. According to other experts, however, these paintings have little or nothing to do with Vermeer.[90]

A much more serious attempt to enlarge Vermeer's early oeuvre was recently made by Arthur Wheelock, who argued for the acceptance of *St Praxedis*.[91] This painting — which was included in the large Vermeer exhibition of 1995–1996, held in

Washington and The Hague (fig. 45) — depicts a female saint who lived in Rome in the second century after Christ and cared for the mortal remains of Christians martyred for their faith. At first glance the painting seems Italian, in both style and subject matter, and when the canvas was first exhibited in New York in 1969, it was thought to be the work of the Florentine painter Felice Ficherelli (1605– c.1669). But because *Meer 1655* was legible in the lower left-hand corner, the critic Michael Kitson connected the painting to Johannes Vermeer, referring to the 'open-endedness' of his early work.[92] After Hannema, too, had spoken approvingly of this attribution in the 1970s, the painting was published in 1986 as a Vermeer by Wheelock, who backed up his opinion with extensive arguments, including comparison of the painting technique with that of Vermeer's early works.[93] In his view, *St Praxedis* was a copy after a composition by Ficherelli, of which the original, dating from around 1645, had meanwhile been located in a private collection in Ferrara. Wheelock argued that Vermeer could have copied this so manifestly Catholic subject for someone from the circle of his Catholic mother-in-law, Maria Thins, but he could not explain where Vermeer might have seen the Italian original.

During the 1995–1996 Vermeer exhibition, there was an opportunity to examine *St Praxedis* more closely and to compare it with other early works. This led Jørgen Wadum, then chief conservator at the Mauritshuis, to cast doubt on its attribution to Vermeer.[94] He found that the painting technique seen in *St Praxedis* differed so much from that of *Diana and her Nymphs* and *Christ in the House of Martha and Mary* that it could not possibly be by the same hand. He also regarded the signature as a later addition.[95] Wadum did, however, detect striking similarities to other works by Ficherelli, whom he therefore suspected to be the author of the painting. Other connoisseurs, too, openly cast doubt on the attribution of *St Praxedis* to Vermeer, and the painting has since ceased to attract attention.[96] In his 2008 monograph on Vermeer, Walter Liedtke does not even mention it. Indeed, it appears that this attempt to add another early work to Vermeer's oeuvre has also proved unsuccessful, but there will undoubtedly be new discoveries.

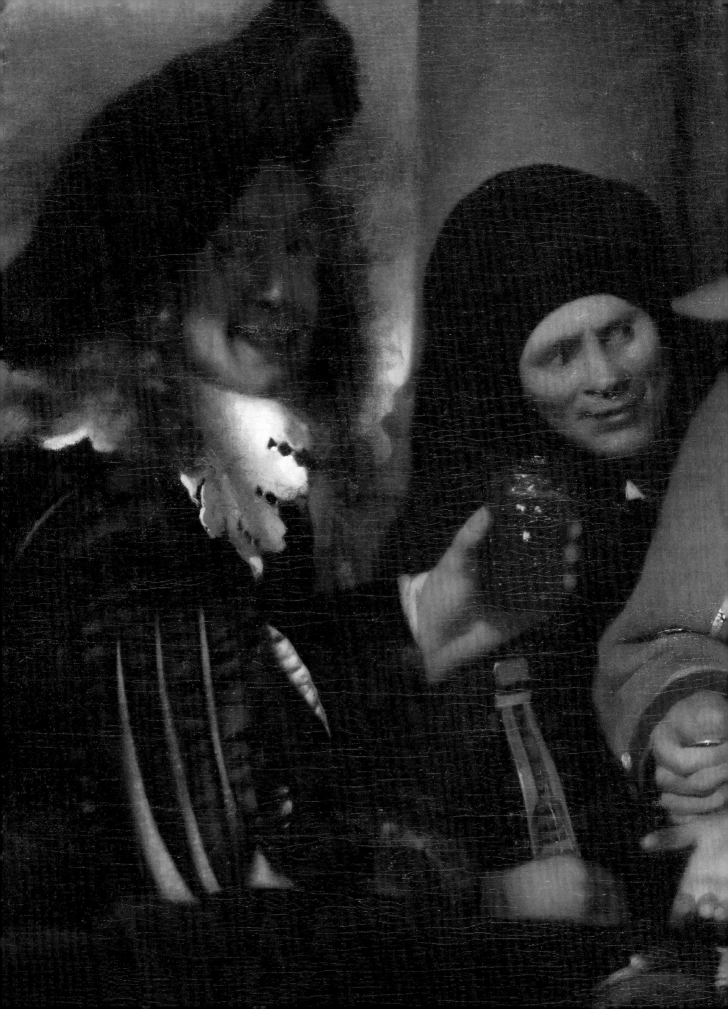

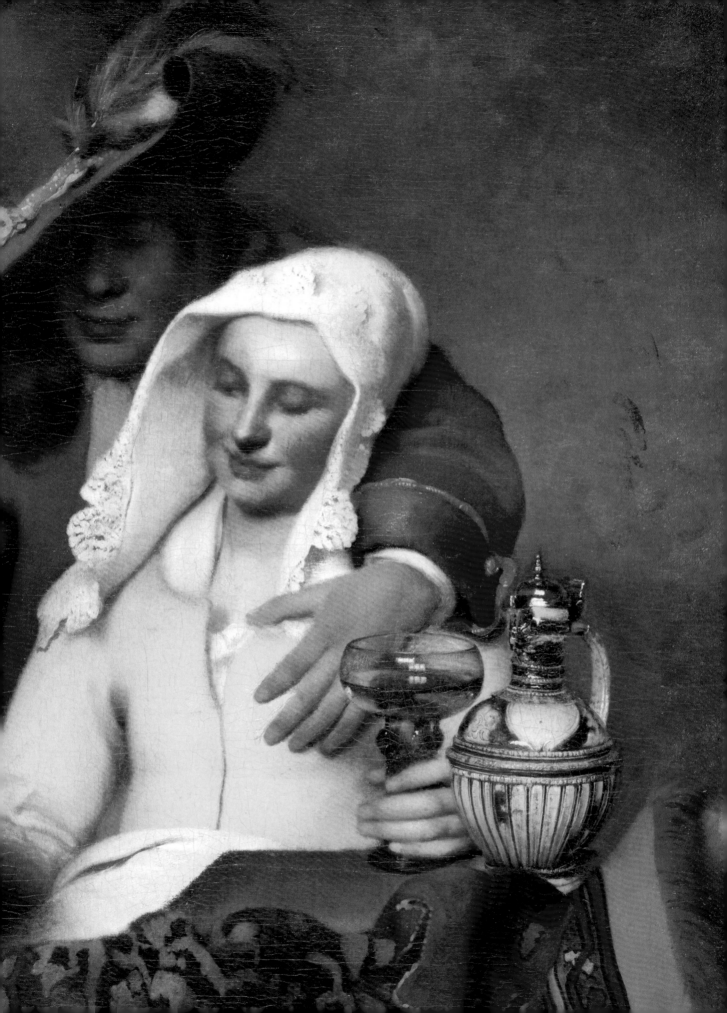

Vermeer, Vermeer and Vermeer

Geerte Broersma

Alongside Johannes Vermeer of Delft, two contemporary painters with the same name were active in other cities: Jan Vermeer of Utrecht (1630–1695/97) and Jan Vermeer of Haarlem (1628–1691).[97] Despite the growing interest shown in the nineteenth century in the Delft Vermeer, information on his life and work remained in short supply.[98] He had been forgotten for more than a hundred years, which made it easy to confuse this artist with two others who signed their work with the same surname.[99]

In 1859 Thoré-Bürger discovered that *The Procuress* must have been painted by the Delft Vermeer and not Vermeer of Utrecht, as previously assumed (see p. 86, note 61). At the end of the nineteenth century, this Vermeer of Utrecht again became an object of attention when Bredius named him as the author of *Diana and her Nymphs* (see p. 57).

Jan Vermeer of Utrecht was baptised in 1630 in Schipluiden.[100] He possibly studied with the Rotterdam painter Ludolf de Jongh (1616–1679). Between about 1653 and 1659 he travelled to Rome, together with the Rotterdam artist Lieve

46　Jan Vermeer van Utrecht, *Regents of the Utrecht City Orphanage*, c.1680. Canvas, 276 × 436 cm. Utrecht, Fundatie van Renswoude.

Verschuier (1627–1686). This Italian sojourn prompted Bredius, who thought he detected Italian influence in *Diana and her Nymphs*, to assume that the Utrecht Vermeer had painted it. After marrying in 1662, Jan Vermeer settled in Utrecht, where he became a member of the painters' guild. In 1683 he moved to Vreeswijk and remarried. He died some time between 1695 and 1697. Though mentioned frequently in the eighteenth-century literature, the Utrecht Vermeer is now virtually unknown.[101] Only one painting can firmly be attributed to him on the basis of documentation: *Regents of the Utrecht City Orphanage* (fig. 46). This large, unsigned group portrait was very likely produced in 1680.[102] Its style clearly differs from that of the Delft Vermeer.

The Haarlem Vermeer is known to have been baptised in Haarlem in 1628 and died there in 1691.[103] At the age of ten he became a pupil of Jacob de Wet (*c*.1610–in or before 1691), but did not register with the Haarlem Guild of St Luke until 1654. He married and had three sons, two of whom also became painters. His eldest son, Jan Vermeer II (1656–1705), painted Italianate landscapes in the style of Nicolaes Berchem. We know ornate still lifes by the middle son, Barent Vermeer (1659–before 25 August 1702).[104]

In 1866, when Thoré-Bürger made a list of paintings by Johannes Vermeer of Delft, he included a number of signed landscapes that

47 Jan Vermeer van Haarlem, *Landscape on the Edge of the Dunes*, 1648. Panel, 52 × 68 cm. The Hague, Mauritshuis.

he could not ascribe with certainty to either the Delft or the Haarlem Vermeer.[105] They have meanwhile been attributed to Vermeer of Haarlem. The oeuvres of these two painters differ considerably in both subject matter and style. Jan Vermeer of Haarlem painted landscapes — particularly views of dunes (fig. 47) — in the style of Jacob van Ruisdael (1628?–1682), whom he is thought to have known personally.[106]

In the nineteenth century, the Delft Vermeer was often confused with the Vermeers of Haarlem and Utrecht. Nowadays these latter Vermeers are known only to a few specialists, whereas Johannes Vermeer of Delft is known throughout the world.

Works Exhibited

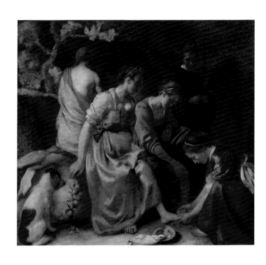

Works Exhibited

1 *Diana and her Nymphs, c.1653–1654*
Canvas, 97.8 × 104.6 cm
At the lower left, on the stone between the
dog and the thistle: *.VMeer.* (VM interlaced;
fig. 48a and d)
The Hague, Royal Picture Gallery
Mauritshuis, inv. no. 406

▸ PROVENANCE
Art dealer Dirksen, The Hague, before 1866 (sold for 175 guilders
to Goldsmid); Neville Davison Goldsmid, The Hague, before
1866–1875; his widow, Eliza Garey, The Hague and Paris, 1875–
1876 (Goldsmid sale, Paris, 4 May 1876, lot 68, as Nicolaes Maes);
purchased for 10,000 French francs by Victor de Stuers for the
Dutch state

▸ SELECTED LITERATURE
Blankert/Montias/Aillaud 1987, pp. 71–73, 171, no. 2; Nash 1991,
pp. 44, 46–47; M. de Boer in Broos 1993, pp. 306–314, no. 37;
Wheelock 1995, pp. 29–37; Washington-The Hague 1995–1996,
pp. 96–101, no. 3; A. Blankert in Rotterdam-Frankfurt 1999–2000,
pp. 312–315, no. 62; Liedtke 2000, pp. 191–194; New York-London
2001, pp. 359–363, no. 64; Kolfin/Pottasch/Hoppe 2002; Noble *et al.*
2009, pp. 156–167, no. 11; Liedtke 2008, pp. 22–24, 56–59, no. 1

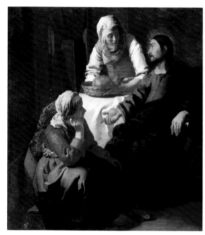

2 *Christ in the House of Martha and Mary*, c.1654–1655
 Canvas, 160 × 142 cm
 At the lower left on the foot-stool: *IvMeer.*
 (IvM interlaced; fig. 49)
 Edinburgh, National Gallery of Scotland,
 inv. no. 1670 (bequest of the heirs of Coats,
 in memory of their father)

3 *The Procuress*, 1656
 Canvas, 143 × 130 cm
 Lower right: *IvMeer. / 1656.*
 (IvM interlaced; fig. 50)
 Dresden, Gemäldegalerie Alte Meister,
 Staatliche Kunstsammlungen,
 inv. no. 1335

▸ PROVENANCE
(?)John Hugh Smyth Pigott, Brokley Hall, 1829; (?)Abbot
collection, Bristol, c.1880; unknown antique dealer, Bristol (sold
in 1884 to a private individual for £10 and bought back for £13);
Arthur Leslie Collie, London; art dealer Forbes & Paterson,
London, 1901 (sold to Coats); William Allan Coats, Skelmorlie
Castle, Dalskairth, Dumfries and Galloway, Scotland, 1901–1926;
by descent to his sons Thomas H. Coats and J.A. Coats, 1926–1927
▸ SELECTED LITERATURE
Blankert/Montias/Aillaud 1987, pp. 75–77, 170, no. 1; Nash 1991,
pp. 44–46; Edinburgh 1992, pp. 150–151, no. 71; Washington-
The Hague 1995–1996, pp. 90–95, no. 2; Liedtke 2000, pp. 194–198;
New York-London 2001, pp. 363–365, no. 65; Kolfin/Pottasch/
Hoppe 2002, pp. 92, 98–100; Liedtke 2008, pp. 24–25, 27, 60–61,
no. 2

▸ PROVENANCE
(?)Willem Six sale, Amsterdam, 12 May 1734, lot 92, as 'De Vyf
Sinnen [door Hondhorst.] ('The Five Senses, by Hondhorst)';[107]
collection of the Counts of Waldstein, Dux (Duchcov) near Teplice,
Czech Republic (inventory 1737, fol. 6. no. 33, as 'ein
Stuck mit vier Persohnen in Lebens-Grösse von Hondhorst'
['a piece with four persons, life-size, by Hondhorst']);[108]
acquired from this collection for Friedrich August II (1696–1763),
Elector of Saxony (= Augustus III, King of Poland), Dresden,
1741 (inventory 1750, fol. 36, no. 130, as 'Giovanni van der Meer')
▸ SELECTED LITERATURE
Blankert/Montias/Aillaud 1987, pp. 87–90, 171–172, no. 3; Nash
1991, pp. 50–53; Liedtke 2000, pp. 199–202; New York-London 2001,
pp. 365–368, no. 66; Kolfin/Pottasch/Hoppe 2002, pp. 92, 98–100;
Dresden 2004; Liedtke 2008, pp. 26–27, 62–65, no. 3

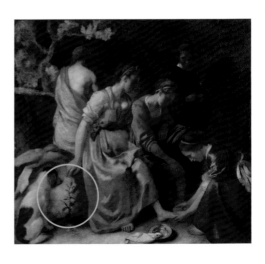

▸ SIGNATURE

When the canvas was bought for the Mauritshuis in 1876, it bore a signature: *NMaes* (fig. 48b). In 1885 this signature proved a forgery. Beneath it appeared a vaguely visible, original signature legible as *JVMeer* (VM interlaced; fig. 48c). Now only the letters *VMeer* are still discernible (fig. 48d).

48a Detail of the signature.

48c Facsimile of the signature, published in 1895.

48b Detail of the forged signature *NMaes* from a photo-engraving by Hanfstaengl, published in 1890.

48d Facsimile of the signature, made during the 1999–2000 conservation treatment (Carol Pottasch, Mauritshuis, The Hague).

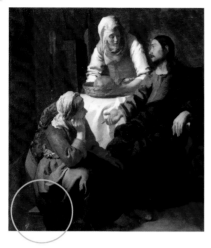

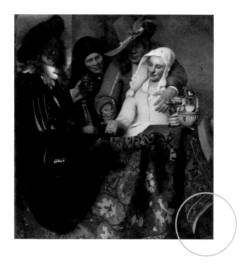

▸ SIGNATURE

An IvM monogram, similar to the one seen on *Christ in the House of Martha and Mary* and *The Procuress*, occurs on *View of Delft* of c.1660–1661.

49 Detail of the signature.

50 Detail of the signature and date.

Notes and Bibliography

Notes

I would like to thank the institutions and persons who have contributed to this publication. My research relied heavily on the documentation in the Netherlands Institute for Art History (RKD) in The Hague, and I am greatly indebted to its director, Rudi Ekkart, and to his staff for their hospitality and helpfulness. In compiling this publication, I received the invaluable help and advice of Uta Neidhardt, Curator of Dutch Art at the Gemäldegalerie Alte Meister, Staatliche Kunstsammlungen Dresden, and Christian Tico Seifert, Senior Curator of Northern European Art, The National Gallery of Scotland, Edinburgh. I am also grateful to my colleagues at the Mauritshuis. Emilie Gordenker, Quentin Buvelot and Epco Runia commented on an earlier version of the text. Geerte Broersma not only contributed a piece to this publication, but also took responsibility for assembling the photographic material reproduced here. Carol Pottasch shared the knowledge of the painting technique and state of preservation of *Diana and her Nymphs* that she acquired while carrying out conservation treatment and technical research on the painting in 1999-2000.

The various publications on Johannes Vermeer by Albert Blankert, Arthur Wheelock, Walter Liedtke and John Michael Montias were indispensable as source material. The in-depth study *Johannes Vermeer: Bei der Kupplerin*, edited by Uta Neidhardt and Marlies Giebe and published in 2004 by the museum in Dresden, offered a great deal of information on *The Procuress*.

1 The number of 36 works is based on Liedtke 2008. Regarding Vermeer's oeuvre, see also Blankert/Montias/Aillaud 1987, Wheelock 1995 and Washington-The Hague 1995-1996.
2 The information now available on Vermeer's life and milieu is largely due to the pioneering research done by John Michael Montias (1928-2005). The information given here on Vermeer's family was (unless otherwise stated) taken from Montias 1989, esp. chapters 4 and 6. No documents pertaining to Johannes Vermeer himself are known from the period 1632-1653. On Vermeer's youth and training, see also Blankert/Montias/Aillaud 1987, pp. 34-37, 70-72, Franits 2001, pp. 8-12, and Liedtke 2008, pp. 11-16.
3 Van der Veen 1996, pp. 128-129.
4 Van der Veen 1996, pp. 132-133; Jansen 2009, pp. 16-18.
5 Montias 1982, p. 88; Montias 1989, p. 103; Van der Veen 1996, p. 126.
6 Thoré-Bürger 1858-1860, vol. 2, p. 80; Thoré-Bürger 1866, p. 312. For a repudiation of this hypothesis, see MacColl 1901, pp. 9-11.
7 Blankert/Montias/Aillaud 1987, pp. 154-155, 211, doc. 1667; Montias 1989, p. 104; Wheelock 1995-1996, p. 15; The Hague-Schwerin 2004-2005, p. 63.
8 Montias 1989, pp. 100, 103-104; Blankert/Montias/Aillaud 1987, pp. 34, 70-71; Liedtke 2008, pp. 20-21. On Bramer, see Delft 1994. Also suggested as Vermeer's teacher in Delft are Evert van Aelst and Egbert van der Poel who, as mentioned earlier, were acquainted with Vermeer's father. The paintings of the young Vermeer bear little resemblance to their work, however: Van Aelst was a still-life painter and Van der Poel

was specialised in landscapes and 'fires' ('brandjes').
9 Montias 1989, pp. 102-103; Washington-Detroit 2004-2005, pp. 15-16.
10 Montias 1989, pp. 106-107 (see pp. 105-106, with regard to the possibility that Vermeer received his artistic training in Amsterdam).
11 Van der Veen 1996, p. 126.
12 Liedtke 2000, pp. 189-190; Liedtke 2001; Liedtke 2008, pp. 16, 20-22.
13 For the concept of 'history painting', see Broos 1993, pp. 10- 29.
14 Broos 1993, p. 22. See also Washington-London-Amsterdam 2001-2002, pp. 88-90 (Cuyp); The Hague 1994-1995, pp. 21-22, 56-58 (Potter); Manke 1963, pp. 8-9, 77-78 (De Witte); Waiboer 2005 (Metsu); Haarlem-Zürich-Schwerin 2006-2007, pp. 13-14 (Berchem).
15 Bredius 1915-1922, vol. 1, p. 233. See also Montias 1989, pp. 139-140 and p. 312, doc. 269.
16 Montias 1989, p. 140; Montias et al. 1991, p. 46, no. 7 (the reference to fig. 2 should be to fig. 3); Broos 1995-1996, p. 48; Liedtke 2008, p. 27.
17 On this subject, see Liedtke 2000, p. 197, and Liedtke 2008, p. 57, from which source the datings chosen here were taken. In Washington-The Hague 1995-1996, pp. 90-101, nos. 2-3, *Christ in the House of Martha and Mary* is dated c.1655 and *Diana and her Nymphs* c.1655-1656. In Blankert/Montias/Aillaud 1987 both works are placed in the period c.1654-1656.
18 Sluijter 2006, pp. 165-193.
19 Liedtke 2000, p. 193; Liedtke 2008, p. 57.
20 This conservation treatment was carried out in the conservation studio of the Mauritshuis by Carol Pottasch, Ruth Hoppe and Caroline van der Elst. For a detailed account

of the conservation treatment and technical research, see Kolfin/Pottasch/Hoppe 2002 and Noble *et al.* 2009, pp. 156–167, no. 11.

21 Prussian blue was available starting in 1704, and chrome green from *c.*1840; Noble *et al.* 2009, p. 164.

22 Noble *et al.* 2009, p. 166.

23 On this subject, and for other possible symbols in this composition, see Washington-The Hague 1995–1996, p. 98, and Liedtke 2008, p. 59.

24 Regarding the painting technique of *Diana and her Nymphs*, see Kolfin/Pottasch/Hoppe 2002, pp. 96–99, and Noble *et al.* 2009, p. 164.

25 Liedtke 2008, p. 57.

26 In *A Maid Asleep* of *c.*1656–1657 (fig. 31), Vermeer had originally included a dog in the composition, but he later painted it out.

27 The similarities between the two paintings were first observed by Bode 1906, p. 50. Other paintings of this subject by Jacob van Loo can also be connected with the composition of Vermeer's *Diana and her Nymphs*. The pose of the sitting figure touching her foot, which Van Loo used frequently, derives from a famous statue of antiquity, *Lo Spinario* (the thorn puller), of which numerous copies and versions were known (see the references to the literature in the following note).

28 Regarding the possible sources of inspiration for Vermeer's *Diana and her Nymphs*, which include Rembrandt's *Bathsheba* of 1654, see Washington-The Hague 1995–1996, p. 98; Gowing 1997, pp. 95–96; A. Blankert in Rotterdam-Frankfurt 1999–2000, pp. 312–315, no. 62; Liedtke 2000, pp. 193–194; Liedtke 2008, p. 57.

29 For example, De Vries 1939, p. 32.

30 Montias 1989, pp. 333–334, doc. 341.

31 Washington-The Hague 1995–1996, pp. 92–94.

32 Montias 1989, p. 308, doc. 249.

33 On this subject, see also Begheyn 2008, pp. 44–46.

34 Buijs 1989; Wagner-Douglas 1999 (with regard to the painting by Vermeer, pp. 250–252). In Delft, Christiaen van Couwenbergh had portrayed this biblical story as early as 1629 on a large canvas, which, however, bears no resemblance to Vermeer's composition; New York-London 2001, fig. 59 on p. 59.

35 On the painting technique seen in *Christ in the House of Martha and Mary*, see N. Costaras in Washington-The Hague 1995–1996, p. 90; Kolfin/Pottasch/Hoppe 2002, pp. 98–99.

36 A few small changes to the composition are also discernible in *Diana and her Nymphs*, in the area of the skirt and the foot of the nymph kneeling at the far right.

37 De Bruyn 1988, p. 143, no. 66.

38 For examples of works with similar figures and/or compositional schemes, see E. Trautscholdt in Thieme/Becker 1940, p. 267; Hannema 1972, pp. 32–35; Blankert/Montias/Aillaud 1987, pp. 76–77; Washington-The Hague 1995–1996, p. 92; M.C. Plomp in Delft 1996, pp. 24–25; Gowing 1997, pp. 79–84; Wagner-Douglas 1999, p. 251; Liedtke 2008, p. 60.

39 Liedtke 2008, p. 24: 'Vermeer combined the emotive movement of Van Dyck's religious pictures with the strong light and modelling of Hendrick ter Brugghen, from whose figure types the seated Mary descends'.

40 For detailed information on all aspects of this painting, see Dresden 2004.

41 De Winkel 1998, p. 334.

42 Liedtke 2000, p. 200; Blankert 2004a, p. 22. These publications refer to the instrument incorrectly as a lute. On the cittern, see The Hague-Antwerp 1994, p. 363; Dresden 2004, p. 93.

43 For examples of self-portraits included in genre pieces, see Perry Chapman 1996–1997, pp. 17–19.

44 Neidhardt 2004, pp. 17–18.

45 Renger 1970; The Hague-Antwerp 1994, pp. 146–149; Kolfin 2005, pp. 17–24.

46 Blankert/Montias/Aillaud 1987, pp. 87–90, 208: document 27 November 1641.

47 Regarding these two interiors, see Liedtke 2008, nos. 16 and 34.

48 Neidhardt 2004, pp. 11–12; Liedtke 2008, p. 63.

49 Blankert/Montias/Aillaud 1987, pp. 70–71, 90; Blankert 2004a, p. 25; Liedtke 2008, p. 63.

50 In writing the following section, I have made grateful use of the excellent observations of Uta Neidhardt and Marlies Giebe in Dresden 2004.

51 See Giebe 2004 and Blankert 2004a, pp. 21–22.

52 Giebe 2004, p. 57.

53 Liedtke 2008, pp. 40–42.

54 Ainsworth *et al.* 1982, pp. 18–26; Wheelock 1995, pp. 39–47; Liedtke 2008, pp. 67–68.

55 Gowing 1997, pp. 34–36; Liedtke 2008, p. 71.

56 Blankert/Montias/Aillaud 1987, p. 71. For an overview of Albert Blankert's publications on Vermeer, see Blankert 2004b, pp. 341–343.

57 Broos 1995–1996, pp. 47–54.

58 Montias 1989, pp. 246–262; Broos 1995–1996, pp. 53–54; Liedtke 2008, pp. 36–39.

59 Regarding various ideas about Thoré's role in the rediscovery of Vermeer, see Blankert/Montias/ Aillaud 1987, pp. 160–162; Broos 1995–1996, pp. 59–60; Hertel 1996, pp. 95–98; Jowell 1998 (with references to previous literature); Broos 1998. For the mention of works by Vermeer in lexicons and catalogues from the first half of the nineteenth century, see Broos 1995–1996, p. 59.

60 Thoré-Bürger 1858–1860, vol. 1, pp. 272–273. For an account of Thoré-Bürger's first visit to the Mauritshuis in 1842, see Thoré-Bürger 1866, p. 298.

61 Thoré-Bürger 1858–1860, vol. 2, pp. 67–88; quotation on p. 79. In the catalogues of the Dresden museum, the painting has been recorded since 1826 as a work by 'Jacob van der Meer of Utrecht', probably on the basis of the signature; see Mayer-Meintschel 2004, pp. 31–33. Even before Thoré-Bürger, the English art dealer John Smith had recognised the painting as a work by Vermeer of Delft, but had not published it; see Neidhardt 2004, p. 7.

62 Thoré-Bürger 1866.

63 For the provenance and attribution history of this painting, see M. de Boer in Broos 1993, pp. 306–314.

64 Quoted from a letter written by Bredius to the Minister of Internal Affairs (J.P.R. Tak van Poortvliet), 7 June 1892, no. 124 (documentation archives, Mauritshuis). See also Mauritshuis 1895, pp. 447–448, no. 406 (194). On Bredius as an art connoisseur and museum director, see De Boer et al. 1991.

65 Veth/'t Hooft 1895.

66 Mauritshuis 1897, p. 85, no. 406.

67 NRC, 11 March 1901.

68 MacColl 1901.

69 NRC, 26 March 1901.

70 Dagblad van Zuid-Holland en 's Gravenhage, 28 March 1901.

71 Bredius, 27 March 1901.

72 Bredius's travel notes, documentation archives, Mauritshuis (unnumbered pages): 'gezien bij Forbes + Robertson; Delftsche (?) Vermeer gem[erkt]: JVMeer. Precies als M[aurits]huis de Diana. Zeer kleurig & geheel dezelfde kleuren. Zonder eenigen twijfel van dezelfde hand maar zonder eenig pointillé; en ook wel onder ital.[iaanse] invloed – zouden dan beiden toch van Utr. [echtse] Vermeer zijn?' ('seen at Forbes + Robertson; Delft (?) Vermeer signed: JVMeer. Exactly like the M[aurits]huis Diana. Very colourful & the same colours precisely. Without a doubt by the same hand but without any pointillé; and also under Ital[ian] influence — could they both be by the Utr[echt] Vermeer after all?') Besides this short note, Bredius gave a detailed description, elsewhere in the same notebook, of Christ in the House of Martha and Mary.

73 Bredius, 29 March 1901.

74 Notebook belonging to Wilhelm Martin, 1889–1901, Netherlands Institute for Art History (RKD), The Hague, p. 126: London, 25 March– 30 March 1901.

75 Dagblad van Zuid-Holland en 's-Gravenhage, 3 April 1901.

76 Jaarverslag (Annual report) Mauritshuis 1901, p. 43 (dated 1 April 1902).

77 See Martin 1904; Veth 1908, p. 4; Kronig 1908, p. 74; Plietzsch 1911, pp. 12–15. Hofstede de Groot 1907,

pp. 588–589, and Hale 1913, pp. 300–304, doubted the attribution of Diana and her Nymphs to the Delft Vermeer. See also Hale 1937, p. 172.

78 Swillens 1950, pp. 157–164: 'works wrongly attributed to Vermeer', a and b. See dismissive reactions in De Vries 1954, Van Gelder 1956 and W. Liedtke in New York-London 2001, p. 145. Bok 1998, p. 67, observed that some of Swillens's arguments deserved closer attention, but did not go into detail.

79 Nash 1991, pp. 44–46, doubted whether Diana and her Nymphs and Christ in the House of Martha and Mary could be by the same hand. See also Kolfin/Pottasch/Hoppe 2002, p. 102, note 20.

80 Fry 1911.

81 Index cards of Hofstede de Groot, RKD, The Hague.

82 A. Blankert in Rotterdam-Frankfurt 1999–2000, pp. 304–307.

83 Another example of a supposedly early Vermeer is Mary Magdalene at the Foot of the Cross, which was shown in 1935 at the large Vermeer exhibition in Rotterdam; Rotterdam 1935, p. 35, no. 79a. See also Kraaijpoel/Van Wijnen 1996, p. 75 and fig. on p. 76.

84 Bredius 1937.

85 Bredius 1938.

86 Hecht 2008, pp. 99–101. For an account of the discovery and purchase of this painting, see Van der Meer Mohr 2006 and Blankert 2006.

87 See the overview in Van Dantzig 1947.

88 See Van den Brandhof 1979; Nash 1991, pp. 48–49; Kraaijpoel/Van Wijnen 1996; Kreuger 2007; Dolnick 2008.

89 See, for instance, Van Regteren Altena 1960.

90 Hannema 1972 and Hannema 1978. On this subject, see also Blankert/ Montias/Aillaud 1987, pp. 163–164, and Balk 2007. Wright 2005, pp. 9–16, accepted one of Hannema's attributions and added several other presumed early works.

91 Canvas, 101.6 × 82.6 cm. The Barbara Piasecka Johnson Collection Foundation, Princeton, NJ. For the story of this discovery, see Gaskell 2000, pp. 32–37.

92 Kitson 1969, p. 410 and pl. XXXIII.

93 Wheelock 1986. See also Wheelock 1995, pp. 21–27; Washington-The Hague 1995–1996, pp. 86–89, no. 1. For Hannema's observations on this painting, see Hannema 1978, p. 95.

94 Wadum 1998, pp. 214–219.

95 At the lower right is another inscription, which has been read as: [Ver]Meer N[aar] R[ip]o[s]o (Riposo was Ficherelli's nickname); Wheelock 1986, pp. 74–75. According to Wadum, however, this inscription was 'so rudimentary that any interpretation would be factitious'; Wadum 1998, p. 219.

96 See Liedtke 2000, p. 194, Gaskell 2000, pp. 36–37, and Boone 2002.

97 There are a number of variants of both painters' names. Jan Vermeer of Utrecht, for example, is also known as Jan, Johannes or Jacob van der Meer (of Utrecht). Jan Vermeer of Haarlem also occurs as Jan van der Meer (of Haarlem). For name variants, see the database RKDartists& at www.rkd.nl.

98 The eighteenth-century artists' biographer Arnold Houbraken mentioned the Delft Vermeer only in passing in his Groote schouburgh, which is why he was long forgotten; Houbraken 1718–1721, vol. 1, p. 236.

99 For more information on the various Vermeers in the eighteenth-century literature, see Weber 1993.

100 The biographical information was taken from Bok 1998, pp. 69–73.

101 Houbraken devoted a lot of attention to the Utrecht Vermeer; Houbraken 1718–1721, vol. 3, pp. 291–292. See also Weber 1993.

102 Bok 1998, p. 69; Muller 1888, pp. 25–28.

103 The biographical information was taken from Van Thiel-Stroman 2006, pp. 320–322.

104 See Van Thiel-Stroman 2006, p. 321.

105 Thoré-Bürger 1866, pp. 307, 571–574, nos. 59–71.

106 Haak 1984, p. 387; Van Thiel-Stroman 2006, p. 321; Giltaij 2009, p. 152.

107 Mayer-Meintschel 2004, p. 34.

108 Mayer-Meintschel 2004, pp. 31, 33, 34.

Ainsworth *et al.* **1982**
M.W. Ainsworth, J. Brealey, E. Haverkamp-Begemann, P. Meyers, *Art and Autoradiography: Insights into the Genesis of Paintings by Rembrandt, Van Dyck, and Vermeer*, New York (The Metropolitan Museum of Art) 1982

Balk 2007
H. Balk, 'Kennerschap en zelfbedrog: Dirk Hannema en Johannes Vermeer', *Kunstschrift* 51 (2007), no. 2, pp. 40–45

Begheyn 2008
P. Begheyn SJ, 'Johannes Vermeer en de jezuïten te Delft', *Oud Holland* 121 (2008), pp. 40–55

Blankert 2004a
A. Blankert, 'Johannes Vermeers "Kupplerin" — neu betrachtet', in Dresden 2004, pp. 21–27

Blankert 2004b
A. Blankert, *Selected Writings on Dutch Painting: Rembrandt, Van Beke, Vermeer and Others*, Zwolle 2004

Blankert 2006
A. Blankert, 'The Case of Han van Meegeren's Fake Vermeer "Supper at Emmaus" Reconsidered', in A. Golahny, M.M. Mochizuki, L. Vergara (eds.), *In his Milieu. Essays on Netherlandish Art in Memory of John Michael Montias*, Amsterdam 2006, pp. 47–57

Blankert/Montias/Aillaud 1987
A. Blankert, J.M. Montias, G. Aillaud, *Vermeer*, Amsterdam 1987 (English ed. New York 1988)

Bode 1906
W. Bode, *Rembrandt und seine Zeitgenossen*, Leipzig 1906

De Boer *et al.* **1991**
M. de Boer, J. Leistra, B. Broos, *Bredius, Rembrandt en het Mauritshuis!!! Een eigenzinnig directeur verzamelt*, The Hague (Mauritshuis) 1991

Bok 1998
M.J. Bok, 'Not to Be Confused with the Sphinx of Delft: The Utrecht Painter Johannes van der Meer (Schipluiden 1630–1695/1697 Vreeswijk?)', in Gaskell/Jonker 1998, pp. 67–79

Boone 2002
J. Boone, 'Saint Praxedis: Missing the Mark', *Essential Vermeer* (www.essential vermeer.com/saint_praxedis.html), 11 July 2002

Van den Brandhof 1979
M. van den Brandhof, *Een vroege Vermeer uit 1937: Achtergronden van leven en werken van de schilder/vervalser Han van Meegeren*, Utrecht, Antwerp 1979

Bredius 27 March 1901
A. Bredius, 'De nieuwe "Delftsche" (?) Vermeer te Londen. (Ingezonden.)', *Nieuwe Rotterdamsche Courant* 27 March 1901 (cutting preserved in the Department of Press Documentation, RKD, The Hague)

Bredius 29 March 1901
A. Bredius, 'De Vermeer te Londen', *Nieuwe Rotterdamsche Courant* 29 March 1901 (cutting preserved in the Department of Press Documentation, RKD, The Hague)

Bredius 1915–1922
A. Bredius, *Künstler-Inventare*, 7 vols., The Hague 1915–1922

Bredius 1937
A. Bredius, 'A New Vermeer', *The Burlington Magazine* 71 (1937), p. 211

Bredius 1938
A. Bredius, 'Nog een woord over Vermeer's Emmausgangers', *Oud Holland* 55 (1938), pp. 97–99

Broos 1993
B. Broos, *Intimacies & Intrigues: History Painting in the Mauritshuis*, The Hague, Ghent 1993

Broos 1995–1996
B. Broos, '"Un celebre Peijntre nommé Verme[e]r"', in Washington-The Hague 1995–1996, pp. 47–65

Broos 1998
B. Broos, 'Vermeer: Malice and Misconception', in Gaskell/Jonker 1998, pp. 19–33

De Bruijn 1988
J.P. de Bruyn, *Erasmus II Quellinus (1607–1678): De schilderijen met catalogue raisonné*, Freren 1988

Buijs 1989
H. Buijs, 'Voorstellingen van Christus in het huis van Maria en Martha in het zestiende-eeuwse keukenstuk', *Nederlands Kunsthistorisch Jaarboek* 40 (1989), pp. 93–128

Dagblad van Zuid-Holland en 's-Gravenhage, 28 March 1901
'Beeldende kunst: Mauritshuis', *Dagblad van Zuid-Holland en 's-Gravenhage* 28 March 1901 (cutting preserved in the Department of Press Documentation, RKD, The Hague)

Dagblad van Zuid-Holland en 's-Gravenhage, 3 April 1901
'Beeldende kunsten: De nieuwe Delftsche Vermeer', *Dagblad van Zuid-Holland en 's-Gravenhage* 3 April 1901 (cutting preserved in the Department of Press Documentation, RKD, The Hague)

Van Dantzig 1947
M.M. van Dantzig, *Johannes Vermeer, de "Emmausgangers" en de critici*, Leiden, Amsterdam 1947

Delft 1994
J. ten Brink Goldsmith et al., *Leonaert Bramer 1596-1674. Ingenious Painter and Draughtsman in Rome and Delft*, Delft (Stedelijk Museum Het Prinsenhof) 1994

Delft 1996
M.C.C. Kersten, D.H.A.C. Lokin, M.C. Plomp, *Delft Masters: Vermeer's Contemporaries: Illusionism through the Conquest of Light and Space*, Delft (Stedelijk Museum Het Prinsenhof) 1996

Dolnick 2008
E. Dolnick, *The Forger's Spell: A True Story of Vermeer, Nazis, and the Greatest Art Hoax of the Twentieth Century*, New York 2008

Dresden 2004
U. Neidhardt, M. Giebe (eds.), *Johannes Vermeer: Bei der Kupplerin*, Dresden (Staat-

liche Kunstsammlungen Dresden, Gemäldegalerie Alte Meister) 2004

Edinburgh 1992
J.L. Lloyd Williams, *Dutch Art and Scotland: A Reflection of Taste*, Edinburgh (National Gallery of Scotland) 1992

Franits 2001
W. Franits, 'Johannes Vermeer. An Overview of His Life and Stylistic Development', in W.E. Franits (ed.), *The Cambridge Companion to Vermeer*, Cambridge 2001, pp. 8–26

Fry 1911
R. Fry, 'Diana and her nymphs', *The Burlington Magazine* 19 (1911), pp. 206–211

Gaskell 2000
I. Gaskell, *Vermeer's Wager. Speculations on Art History, Theory and Art Museums*, London 2000

Gaskell/Jonker 1998
I. Gaskell, M. Jonker (eds.), *Vermeer Studies: Studies in the History of Art* 55, Washington, New Haven, London 1998

Van Gelder 1956
J.G. van Gelder, 'Diana door Vermeer en C. de Vos', *Oud Holland* 71 (1956), pp. 245–247

Giebe 2004
M. Giebe, 'Johannes Vermeers "Kupplerin" — Restaurierung und maltechnische Befunde', in Dresden 2004, pp. 39–64

Giltaij 2009
J. Giltaij, 'Tekeningen van Jan (I) van der Meer van Haarlem', *Oud Holland* 122 (2009), pp. 145–154

Gowing 1997
L. Gowing, *Vermeer*, London 1997 (third edition; first edition 1952)

Haak 1984
B. Haak, *The Golden Age: Dutch Painters of the Seventeenth Century*, New York 1984

Haarlem-Zürich-Schwerin 2006-2007
P. Biesboer et al., *Nicolaes Berchem: In the Light of Italy*, Haarlem (Frans Hals Museum), Zürich (Kunsthaus), Schwerin (Staatliches Museum) 2006-2007

The Hague 1994-1995
A. Walsh, E. Buijsen, B. Broos, *Paulus Potter: Paintings, Drawings and Etchings*, The Hague (Mauritshuis) 1994-1995

The Hague-Antwerp 1994
E. Buijsen, L.P. Grijp et al., *Music & Painting in the Golden Age*, The Hague (Hoogsteder & Hoogsteder), Antwerp (Hessenhuis Museum) 1994

The Hague-Schwerin 2004-2005
F.J. Duparc et al., *Carel Fabritius 1622-1654*, The Hague (Mauritshuis), Schwerin (Staatliches Museum) 2004-2005

Hale 1913
P.L. Hale, *Jan Vermeer of Delft*, Boston 1913

Hale 1937
P.L. Hale, *Vermeer*, London 1937

Hannema 1972
D. Hannema, *An Essay on Johannes Vermeer of Delft : Two Unknown Works of the Early Period*, Heino 1972

Hannema 1978
D. Hannema, 'Problemen rondom Vermeer van Delft', *Boymans bijdragen: Opstellen van medewerkers en oud-medewerkers van het Museum Boymans-van Beuningen voor J.C. Ebbinge Wubben*, Rotterdam 1978, pp. 89–103

Hecht 2008
P. Hecht, *125 jaar openbaar kunstbezit met steun van de Vereniging Rembrandt*, Zwolle 2008

Hertel 1996
C. Hertel, *Vermeer: Reception and Interpretation*, Cambridge 1996

Hofstede de Groot 1907
C. Hofstede de Groot, *Beschreibendes und kritsches Verzeichnis der Werke der hervorragendsten holländischen Maler des XVII. Jahrhunderts*, vol. 1, Esslingen, Paris 1907

Houbraken 1718-1721
A. Houbraken, *De groote schouburgh der Nederlantsche konstschilders en schilderessen*, 3 vols., The Hague 1718-1721

Jaarverslag Mauritshuis 1901
A. Bredius, 'Koninklijk Kabinet van Schilderijen' in *Verslagen omtrent 's Rijks verzamelingen van geschiedenis en kunst. XXIV. 1901*, The Hague 1903, pp. 42–50

Jansen 2009
A. Jansen, 'Willem Willemsz. van der Vliet (Delft ca. 1584-1642 Delft), Portret van Willem Reyersz. de Langue (1599-1656), Portret van Maria Jorisdr. Pijnaecker (1599-1678)', *Bulletin van de Vereniging Rembrandt* 19 (2009), no. 3, pp. 14–18

Jowell 1998
F.S. Jowell, 'Vermeer and Thoré-Bürger: Recoveries of Reputation', in Gaskell/Jonker 1998, pp. 35–57

Kitson 1969
M. Kitson, 'Current and Forthcoming Exhibitions: Florentine Baroque Art in New York', *The Burlington Magazine* 111 (1969), pp. 409–410

Kolfin 2005
E. Kolfin, *The young gentry at play. Northern Netherlandish scenes of merry companies 1610-1645*, Leiden 2005

Kolfin/Pottasch/Hoppe 2002
E. Kolfin, C. Pottasch, R. Hoppe, 'The metamorphosis of Diana: Changing perceptions of the young Vermeer's painting technique', *Art Matters* 1 (2002), pp. 90–103

Kraaijpoel/Van Wijnen 1996
D. Kraaijpoel, H. van Wijnen, *Han van Meegeren (1889-1947) en zijn meesterwerk van Vermeer*, Zwolle 1996

Kreuger 2007
F.H. Kreuger, *A new Vermeer: Life and work of Han van Meegeren*, Rijswijk 2007

Kronig 1908
J.O. Kronig, 'Johannes Vermeer ("De Delftsche Vermeer")', *Elsevier's Geïllustreerd Maandschrift* 18 (1908), vol. 36, pp. 73–82

Liedtke 2000
W. Liedtke, *A View of Delft: Vermeer and his Contemporaries*, Zwolle 2000

Liedtke 2001
W. Liedtke, 'Vermeer Teaching Himself',
in W.E. Franits (ed.), *The Cambridge
Companion to Vermeer*, Cambridge 2001,
pp. 27–40

Liedtke 2008
W. Liedtke, *Vermeer: The Complete Paintings*,
Antwerp 2008

MacColl 1901
D.S. MacColl, *A note on Vermeer of Delft
and the picture 'Christ with Martha & Mary'*,
London 1901

Manke 1963
I. Manke, *Emanuel de Witte 1617–1692*,
Amsterdam 1963

Martin 1904
W. Martin, 'Jan Vermeer van Delft',
Woord en Beeld (1904), pp. 3–8

Mauritshuis 1890
A. Bredius, *Die Meisterwerke der königlichen
Gemäldegalerie im Haag: Photogravure-
Prachtwerk mit erläuterndem Text*, Munich
[1890]

Mauritshuis 1895
A. Bredius, C. Hofstede de Groot, *Musée
Royal de La Haye (Mauritshuis). Catalogue
Raisonné des Tableaux et des Sculptures*,
The Hague 1895

Mauritshuis 1897
A. Bredius, *Beknopte catalogus der schilderijen
en beeldhouwwerken van het Koninklijk kabinet
van Schilderijen (Mauritshuis) te 's Gravenhage*,
The Hague 1897

Mayer-Meintschel 2004
A. Mayer-Meintschel, 'Johannes
Vermeers "Kupplerin" — zu Herkunft
und Inhalt', in Dresden 2004, pp. 31–38

Van der Meer Mohr 2006
J. van der Meer Mohr, 'Bredius en zijn
"Emmausgangers van Vermeer". Een
nieuwe reconstructie', *Origine* 14 (2006),
no. 5, pp. 24–29; no. 6, pp. 19–23

Montias 1982
J.M. Montias, *Artists and Artisans in Delft:
A Socio-Economic Study of the Seventeenth
Century*, Princeton 1982

Montias 1989
J.M. Montias, *Vermeer and his Milieu:
A Web of Social History*, Princeton 1989

Montias et al. 1991
J.M. Montias et al., 'A Postscript on
Vermeer and His Milieu', *The Hoogsteder
Mercury* 12 (1991), pp. 42–51

Muller 1888
S. Muller, 'Een regentenstuk van
Johan van der Meer', *Oud Holland* 6 (1888),
pp. 25–32

Nash 1991
J. Nash, *Vermeer*, Amsterdam 1991

Neidhardt 2004
U. Neidhardt, 'Johannes Vermeers
"Kupplerin" — ein Werk des nieder-
ländischen Caravaggismus?', in Dresden
2004, pp. 7–20

New York-London 2001
W. Liedtke et al., *Vermeer and the Delft School*,
New York (The Metropolitan Museum
of Art), London (National Gallery) 2001

Noble et al. 2009
P. Noble, S. Meloni, C. Pottasch, P. van
der Ploeg, E. Runia (ed.), *Preserving our
Heritage: Conservation, Restoration and
Technical Research in the Mauritshuis*,
The Hague, Zwolle 2009

NRC 11 March 1901
'De nieuw ontdekte Vermeer (!)', *Nieuwe
Rotterdamsche Courant*, 11 March 1901
(cutting preserved in the Department of
Press Documentation, RKD, The Hague)

NRC 26 March 1901
'De nieuw ontdekte Vermeer', *Nieuwe
Rotterdamsche Courant*, 26 March 1901
(cutting preserved in the Department
of Press Documentation, RKD,
The Hague)

Perry Chapman 1996-1997
H. Perry Chapman, 'Jan Steen, Player
in His Own Paintings', in H. Perry
Chapman, W. Kloek, A.K. Wheelock, *Jan
Steen: Painter and Storyteller*, Washington
(National Gallery of Art), Amsterdam
(Rijksmuseum) 1996–1997, pp. 11–24

Plietzsch 1911
E. Plietzsch, *Vermeer van Delft*, Leipzig 1911

Van Regteren Altena 1960
J.Q. van Regteren Altena, 'Een jeugdwerk
van Johannes Vermeer', *Oud Holland* 75
(1960), pp. 175–194

Renger 1970
K. Renger, *Lockere Gesellschaft. Zur Ikono-
graphie des Verlorenen Sohnes und von
Wirthausszenen in der niederländischen Malerei*,
Berlin 1970

Rotterdam 1935
*Vermeer: oorsprong en invloed. Fabritius,
De Hooch, De Witte*, Rotterdam (Museum
Boijmans) 1935

Rotterdam-Frankfurt 1999-2000
A. Blankert et. al., *Dutch Classicism in
Seventeenth-Century Painting*, Rotterdam
(Museum Boijmans Van Beuningen),
Frankfurt (Städelsches Kunstinstitut)
1999–2000

Sluijter 2006
E.J. Sluijter, *Rembrandt and the Female Nude*,
Amsterdam 2006

Swillens 1950
P.T.A. Swillens, *Johannes Vermeer. Painter
of Delft 1632-1675*, Utrecht 1950

Van Thiel-Stroman 2006
I. van Thiel-Stroman, 'Johannes Jansz
Vermeer', in N. Köhler et al. (eds.), *Painting
in Haarlem 1500-1850: The collection of the
Frans Hals Museum*, Ghent 2006, pp. 320–
322

Thieme/Becker 1940
U. Thieme, F. Becker, *Allgemeines Lexikon
der bildenden Künstler von der Antike bis zur
Gegenwart*, vol. 34, Leipzig 1940

Thoré-Bürger 1858-1860
W. Bürger (Étienne Joseph Théophile
Thoré), *Musées de la Hollande*, 2 vols., Paris
1858–1860

Thoré-Bürger 1866
W. Bürger (Étienne Joseph Théophile
Thoré), 'Van der Meer de Delft', *Gazette
des Beaux-Arts* 21 (1866), pp. 297–330,
458–470, 542–575

Van der Veen 1996
J. van der Veen, 'The Delft Art
Market in the Age of Vermeer', in
D. Haks, M.C. van der Sman (eds.),
Dutch Society in the Age of Vermeer, The
Hague (Haags Historisch Museum)
1996, pp. 124–135

Veth 1908
J. Veth, *Schilderijen van Johannes
Vermeer in Nederlandsche verzamelingen.*
Vereeniging tot Bevordering van
Beeldende Kunsten. Premie-uitgave,
[s.l.] 1908

Veth/'t Hooft 1895
[J.] Veth, [C.G.] 't Hooft, 'Schilderkunst:
Een vroeg werk van den Delftschen
Vermeer?', *De Kroniek: Een Algemeen
Weekblad* 1 (1895), pp. 227–228

De Vries 1939
A.B. de Vries, *Jan Vermeer van Delft*,
Amsterdam 1939

De Vries 1954
A.B. de Vries, 'Vermeer's Diana',
Bulletin van het Rijksmuseum 2 (1954),
pp. 40–42

Wadum 1998
J. Wadum, 'Contours of Vermeer',
in Gaskell/Jonker 1998, pp. 201–223

Wagner-Douglas 1999
I. Wagner-Douglas, *Das Maria und
Martha Bild: Religiöse Malerei im
Zeitalter der Bilderstürme*, Baden-Baden
1999

Waiboer 2005
A. Waiboer, 'The early years of
Gabriel Metsu', *The Burlington Magazine*
147 (2005), pp. 80–90

Washington-The Hague 1995–1996
A.K. Wheelock et al., *Johannes Vermeer*,
Washington (National Gallery of Art),
The Hague (Mauritshuis) 1995–1996

Washington-Detroit 2004–2005
A.K. Wheelock et al., *Gerard ter Borch*,
Washington (National Gallery of Art),
Detroit (The Detroit Institute of Arts)
2004–2005

**Washington-London-Amsterdam
2001–2002**
A.K. Wheelock (ed.), *Aelbert Cuyp*,
Washington (National Gallery of Art),
London (National Gallery), Amsterdam
(Rijksmuseum) 2001–2002

Weber 1993
G.J.M. Weber, 'Antoine Dézallier
d'Argenville und fünf Künstler namens
Jan van der Meer', *Oud Holland* 107 (1993),
pp. 298–304

Wheelock 1986
A.K. Wheelock, '"St. Praxedis": New light
on the Early Career of Vermeer', *Artibus et
Historiae* 14 (1986), pp. 71–89

Wheelock 1995
A.K. Wheelock, *Vermeer & the Art of Painting*,
New Haven, London 1995

Wheelock 1995–1996
A.K. Wheelock, 'Vermeer of Delft: His
Life and His Artistry', in Washington-
The Hague 1995–1996, pp. 15–29

De Winkel 1998
M. de Winkel, 'The Interpretation of
Dress in Vermeer's Paintings', in Gaskell/
Jonker 1998, pp. 327–339

Wright 2005
C. Wright, *Vermeer*, London 2005 (first
edition 1995)

EDITOR
Edwin Buijsen, Mauritshuis

COPY EDITOR
Dorine Duyster, Amsterdam

TRANSLATOR
Diane Webb, Maastricht

PHOTO EDITOR
Geerte Broersma, Mauritshuis

DESIGNER
DeLeeuwOntwerper(s), The Hague

PRODUCTION
Royal Picture Gallery Mauritshuis Foundation, The Hague

PUBLISHING AND PRINTING
Waanders Publishers and Printers, Zwolle

For more information on the Mauritshuis and Waanders, visit
www.mauritshuis.nl
www.waanders.nl

FRONT COVER
Johannes Vermeer, *Diana and her Nymphs* (detail), c.1653–1654.
The Hague, Mauritshuis (cat. no. 1).

BACK COVER
· Johannes Vermeer, *Diana and her Nymphs*, c.1653–1654. The Hague,
 Mauritshuis (cat. no. 1).
· Johannes Vermeer, *Christ in the House of Martha and Mary*, c.1654–1655.
 Edinburgh, National Gallery of Scotland (cat. no. 2).
· Johannes Vermeer, *The Procuress*, 1656. Dresden, Gemäldegalerie
 Alte Meister, Staatliche Kunstsammlungen (cat. no. 3).

ISBN 978 90 400 7680 0
NUR 646
There is also a Dutch edition of this book.

PHOTO CREDITS
Unless otherwise stated, the photographic material belongs to
the owners mentioned in the captions. To this may be added:
fig. 2: Koninklijke Bibliotheek (KB), The Hague, 75 C 6 (vol. 2),
folio 18 r; figs. 9, 12, 14b, 17b, 45, 48a, pp. 11–16: Ed Brandon;
figs. 13, 32: © Bildarchiv Preußischer Kulturbesitz, Berlin, 2010;
fig. 19: © RMN / René-Gabriel Ojéda; figs. 20, 25, 34, 36, 37, 38, 39,
41, 42, 43, 48b–c: Stichting Rijksbureau voor Kunsthistorische
Documentatie, The Hague; figs. 23, 28, 29, 30a, 50, pp. 68–71:
H.P. Klut, SKD; fig. 24: © 2010 Museum of Fine Arts, Boston,
M. Theresa B. Hopkins Fund, 50.2721; fig. 26: © Landesmuseum
Mainz (Ursula Rudischer); figs. 27, 30b: Gerhard Rüger, SKD;
fig. 31: Bequest of Benjamin Altman, 1913. Acc.n.: 14.40.611
© 2010. Image copyright The Metropolitan Museum of Art/
Art Resource/Scala, Florence.